**·KiDSWORKS·**

# Art
## for All
# Seasons

Written by Susie Alexander
Illustrations by Wendy Chang

**Teacher Created Materials**

Teacher Created Materials, Inc.

P.O. Box 1040

Huntington Beach, CA 92647

©1996 Teacher Created Materials, Inc.

Made in U.S.A.

Library of Congress Catalog Card Number: 95-62418

**ISBN-1-55734-676-3**

**Editor:**

Janet Cain

# Table of Contents

# Table of Contents (cont.)

# Introduction

Welcome to Art for All Seasons! This 160-page book is filled with fun ideas for art activities and was created for parents to use with their children. It will become a valuable resource in planning your activities for all of the seasons and some of the holidays that occur during the year. This book includes many types of projects, with varying degrees of difficulty, so that they can be completed by children from a wide range of ages. Parents will want to take special care with projects that involve using heat or sharp objects.

Although these projects were compiled for kids and parents, they can easily be adapted for the classroom. Teachers need only multiply the amount of materials by the number of students participating to have a new resource for art activities that can be integrated into thematic units for seasons or specific holidays.

The activities in this book make use of materials that are easily obtained. Most of the items you probably already have in your home. Any items that you need to buy can be found in grocery, drug, arts and crafts, and/or teacher supply stores. Recycling can provide many of the items. For example, consider cleaning and saving a variety of empty food containers for future projects. In addition, some projects require materials that are found in nature. It is important to stress to children that they should collect natural things without harming the environment.

If you do not already have an area set aside for storing art supplies, it is a good idea to buy one or more large plastic bins with lids. These bins can be used for a variety of supplies, such as construction paper, child-sized scissors, hole punches, glue, small empty boxes, toilet paper tubes, and anything else your children might need as they work on their artistic creations. Use resealable plastic bags for storing small items like pompons, stickers, yarn scraps, pre-cut shapes, pipe cleaners (chenille sticks), colored sand, etc. Organization makes preparation for each project easy, and it saves time.

# How to Use This Book

**Previewing the Book:** Page through the book to familiarize yourself with the type of art projects and the layout of the sections, which are organized by seasons and holidays. Artwork showing some of the completed projects is included to help clarify the instructions. In addition, the more difficult steps are also illustrated.

**Gathering Materials:** Note things you can begin to collect and recycle as you go about your daily activities. These could include things found in the home, such as plastic bottles, jugs, and six-pack rings; different sized cans; Styrofoam egg cartons and meat trays; and bits of fabric, ribbon, and string. Or you may find things in nature, such as feathers, nuts, rocks, seeds, and leaves. There may be still other items—such as craft sticks, construction paper, scissors, tape, glue, paint, paintbrushes, markers, and crayons—that you will want to purchase to keep on hand.

**Storing Materials:** Use plastic bins or set aside an area, such as a shelf or drawer, that will serve as a permanent place to store all art materials. Make the storage place accessible to your children so they can contribute to the collectibles whenever they find something they think would be fun to use. Remind kids to respect others by asking before they take anything that is not theirs. Tell children to check with you before they take something from the environment so they do not harm living things.

**Getting Started:** The projects in this book can be done in any order and can be changed in any way to suit your needs. Help children get started by reading the directions together and talking about the project they choose. Be sure to check the "Materials" section to ensure you have the necessary materials before children begin working. Older kids will probably be able to complete most of the activities with only a little help. Younger children may need further assistance organizing the materials and following the directions.

**Concerning Safety:** Remember to read the Safety Guidelines (page 7) before each art session to minimize the risk of accidents. Make sure you note the projects that require your continued active involvement because of safety concerns or difficulty. Guide children to choose projects that are appropriate for the amount of time you have available.

**Encouraging Creativity:** You may be tempted to do things yourself, but be patient and remember that these are your children's artistic creations. Contribute only what is necessary for your kids to proceed and be ready to rave about the results—no matter what they look like! Enjoy this creative time with your children and have fun doing art for all seasons.

# Safety Guidelines

## For Adults

1. Remember to read the directions completely and carefully before you help your children start a project.

2. Actively assist with the crafts that need adult supervision for safety—those that require use of an iron, stove, hot-glue gun, tools, or sharp utensils.

3. Thoroughly clean all previously used containers. Add a little chlorine bleach to the cleaning water to kill bacteria.

4. Never use meat trays that have held raw chicken. Egg shells should be rinsed with chlorine bleach to destroy potentially dangerous bacteria.

5. Cover work surfaces with a protective layer of cloth, plastic, cardboard, or newspaper.

6. When working with younger children, parcel out small items, such as buttons and seeds, one at a time. Be sure to stress that these items should never be put in their mouths.

7. Model "safety first" behavior as you work with your children. When you are through using a potentially dangerous implement, turn it off, put it away, or otherwise secure it to prevent injury.

8. Teach children to clean up and put things away in their proper places after completing each activity.

## For Children

Be sure to ask an adult for help when you need to use:

- Sharp objects, such as scissors, knives, pins, and needles
- Hot items, such as irons, hot glue guns, and stoves
- Tools, such as hammers, screwdrivers, and sewing machines

# Fall Leaves

by Lori Radcliffe

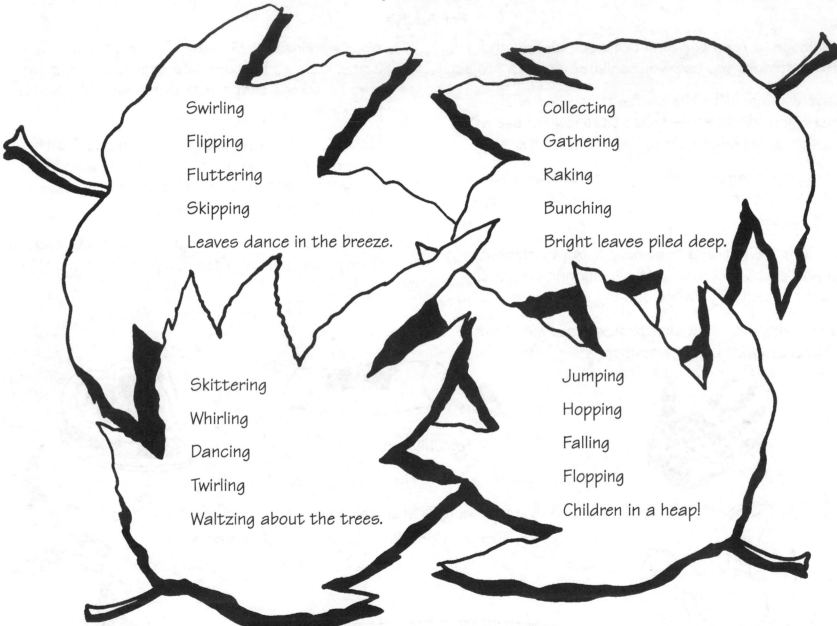

Swirling

Flipping

Fluttering

Skipping

Leaves dance in the breeze.

Collecting

Gathering

Raking

Bunching

Bright leaves piled deep.

Skittering

Whirling

Dancing

Twirling

Waltzing about the trees.

Jumping

Hopping

Falling

Flopping

Children in a heap!

# Autumn Collage

- Styrofoam meat tray
- Natural fall items, such as acorns, leaves, nuts, pine cones, seeds, etc.
- Glue
- Hole punch
- Yarn

1. Collect a variety of fall items that are found in nature.
2. Arrange the items and glue them onto the Styrofoam meat tray.
3. Punch a hole in each of the top corners. Cut a piece of yarn and tie the ends to the holes.
4. Use the yarn to hang the collage.

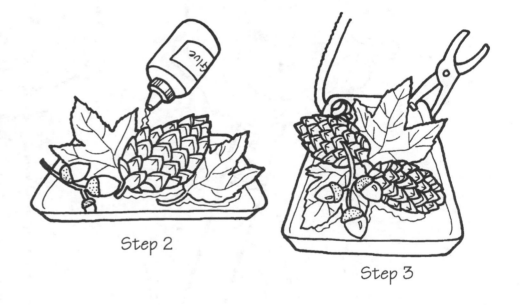

Step 2

Step 3

## MORE IDEAS

- Make a nature collage on the outside of an empty juice can. Place water and fresh flowers in the can. Use it as a centerpiece on your table.
- Some Native Americans used to make necklaces by stringing together acorn caps. See if you can do this!
- Try using seeds and nuts to make pictures of animals and people on paper plates.
- Make a toy, such as a doll, using only natural items.

# Apple People

"An Apple a Day Keeps the Doctor Away."

# Apple People

- Apple
- Knife
- Whole cloves
- Yarn
- Lace and/or ribbon
- Straight pins
- Craft sticks

1. Peel the apple; cut deep slices in the apple to create facial features. Press cloves into the slices to make the eyes and mouth. Make shallow slits for some wrinkles.

2. Place the apples on a cookie sheet in an oven heated to 150° F (65° C). Bake overnight. Allow the apples to cool.

3. Use straight pins to attach hair made from yarn. Decorate with lace, bows, hats, etc., and attach with additional straight pins.

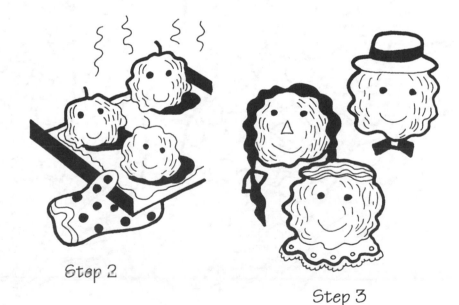

Step 2

Step 3

## MORE IDEAS

- Apply rouge to the cheeks of the apple face for color.
- Insert a stick into the bottom of the apple, so you can use your apple person as an outdoor decoration.
- Read **Johnny Appleseed** by Steven Kellogg (Morrow, 1988) to learn more about the history of apples in America.

# A-Maizing Art

Maize—The Colorful Corn

# A-Maizing Art

- Scissors
- Pencil
- Green, yellow, orange, red, and brown construction paper
- Glue

1. Draw and cut out a maize shape (corn cob) from brown construction paper. Use green construction paper to draw and cut out two pieces of husk.
2. Cut small squares of yellow, orange, and red construction paper to be the kernels of corn. Glue the squares in rows along the length of the maize. The colors can appear in any order.
3. Glue the pieces of husk so they stick out from behind the maize.

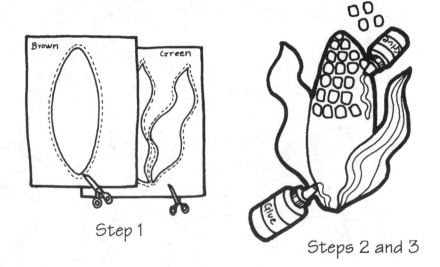

Step 1

Steps 2 and 3

## MORE IDEAS

- Color popcorn, using dry tempera paint (yellow, orange, and red) in plastic bags. Then glue them to the maize shape.
- Tissue paper can be substituted for the construction paper.
- Use cotton swabs and dab paint onto the maize shape to create the kernels of corn.
- Try painting with a real cob of corn. Apply red, orange, yellow, and brown paints. Then roll the corn cob on a piece of paper to create your picture.

# Leaf Stencils

"Turn Over a New Leaf."

# Leaf Stencils

- Leaves of different shapes and sizes
- White construction paper
- Brown, red, yellow, green, and orange tempera paints
- Styrofoam meat trays
- Sponges, cut into squares

1. Place a leaf on the white construction paper.
2. Pour some paint onto a Styrofoam meat tray. Dip the sponge into the paint.
3. Use the sponge to pat some paint around the edges of the leaf.
4. Continue the process using other leaves and different colored paints.

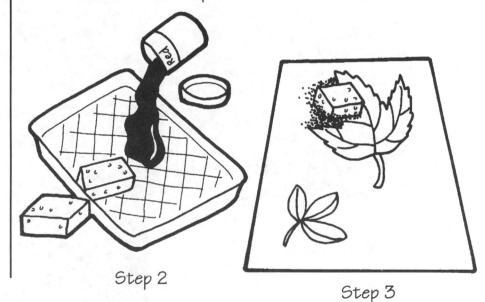

Step 2

Step 3

## MORE IDEAS

- Do not be afraid to mix paint colors with the sponges. It makes for a more authentic-looking leaf.
- Leaf stencils can be used to add a decorative touch to wood, tile, and even windows.
- Take a fall nature walk and identify as many different types of leaves as you can. How many of them change color during the fall? Try to collect one leaf that has fallen from each type of tree and start a leaf collection. Work together to classify the leaves in your collection by grouping them according to similar characteristics, such as color, shape, size, texture, or number of points.

# Sponge-Painted Tree

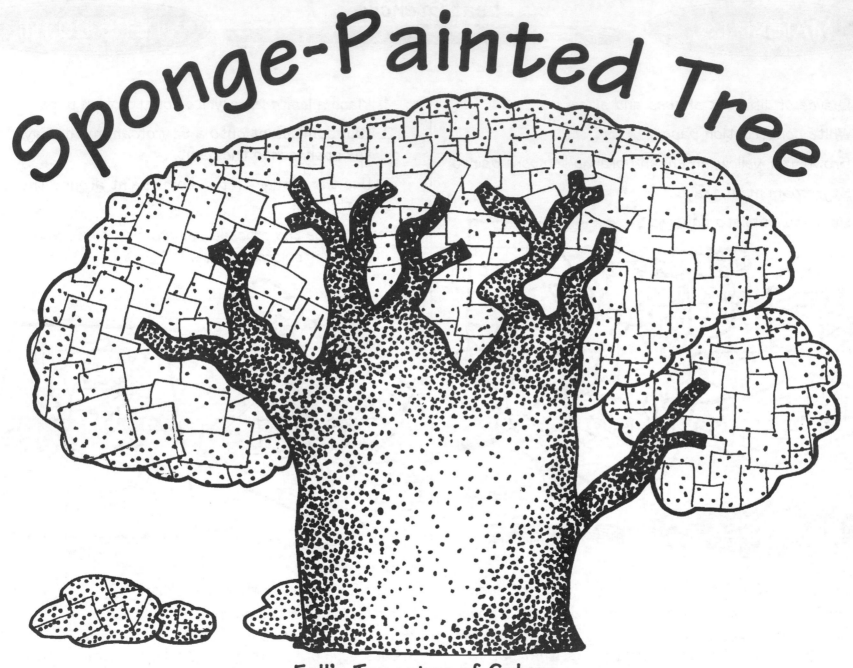

Fall's Tapestry of Colors

# Sponge-Painted Tree

## MATERIALS

- Sponges, cut into small squares
- Brown, yellow, green, orange, and red tempera paints
- Styrofoam meat trays
- White construction paper
- Brown crayon

## LET'S DO IT!!

1. Use the brown crayon to draw the outline of a tree.
2. Pour the paints onto Styrofoam meat trays.
3. Sponge brown paint onto the outline of a tree, completing the trunk and branches.
4. When the brown paint is dry, create fall-colored leaves on the tree by sponging paint onto the branches. You may wish to add some leaves on the ground around the tree and falling from the tree.

Step 3

Step 4

## MORE IDEAS

- After painting the trunk with a sponge, use handprints of brown paint for the branches.
- Draw a large tree. Use hand prints of paint, some keeping your fingers together and others by spreading your fingers apart, to create a variety of fall-colored leaves.
- Use additional paints and sponges to create a scene around the tree.
- Make a mural to show the life of a tree in each of the four seasons. Suggestions: Show a bare tree in the winter, new green leaves and buds (painted fingerprints) in the spring, leaves and fruit in the summer, and colored leaves falling off the tree in the fall.
- Read Janice Udry's **A Tree Is Nice** (HarperCollins, 1956) or Shel Silverstein's **The Giving Tree** (HarperCollins, 1964). Discuss how a tree changes over time.

# Cornhusk Doll

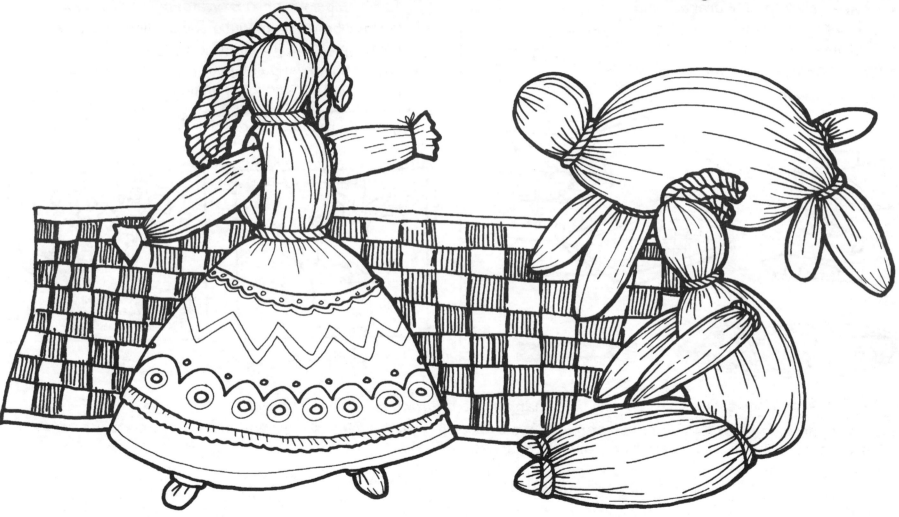

Not All Dolls Come from Toy Stores.

18

# Cornhusk Doll

- Seven cornhusks
- String or yarn
- Scissors
- Paper towels
- Bucket with water

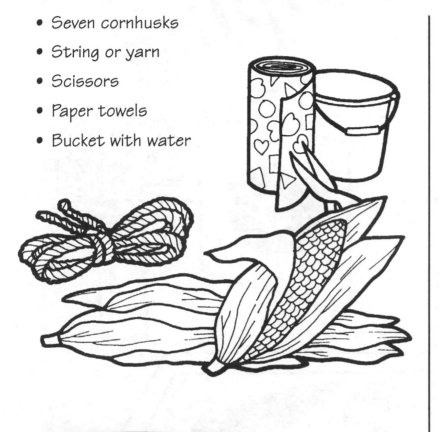

1. Soak the cornhusks in a bucket of water until they are soft. Drain the water but keep the cornhusks damp.
2. Cut six pieces of string, each 4" (10 cm) long.
3. Roll one cornhusk into a tight ball to create the head. Layer five cornhusks then place the ball into the center of the layered cornhusks. Fold the five cornhusks in half over the ball. Tie a piece of string under the ball to make the neck.
4. Make the arms by rolling one cornhusk along its width. Use a piece of string to tie each end. Slide the arms through the middle as illustrated.
5. Tie a piece of string below the arms for the waist.
6. Cut the middle of the loose cornhusks, stopping about 1" (2.5 cm) below the waist. Divide the loose cornhusks into two legs. Use string to tie the bottom of each leg.

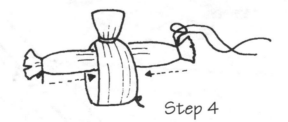

Step 4

## MORE IDEAS

- Using permanent markers, create a face for the doll. Add hair by tying yarn together and gluing it to the head.
- Experiment with braiding and twisting the cornhusks or making cornhusk animals by tying the husks in various places.
- To make a fuller-looking doll, stuff cotton batting into the body of the doll.
- Instead of using cornhusks, make a similar type of doll using yarn.

# Harvest Stamping

## A Fruit and Vegetable Medley

# Harvest Stamping

- Assorted fall fruits and/or vegetables
- Knife
- Variety of paint colors
- Styrofoam meat trays
- White construction paper

1. Pour some paint onto the meat trays. Cut the fruits/vegetables into sections.

2. Dip a fruit/vegetable section into the paint.

3. Stamp the fruit/vegetable section on the paper. Continue stamping additional fruit/vegetable sections with a variety of colors.

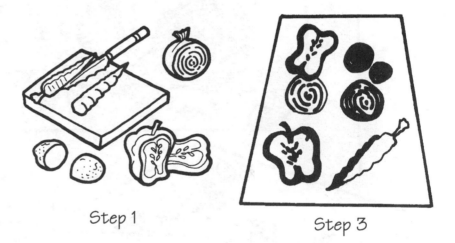

Step 1

Step 3

## MORE IDEAS

- Cut the fruits and/or vegetables in different ways: crosswise for an apple and corn and lengthwise for a carrot.

- Many fruits and vegetables have distinct textures on their skins or peels. Use the outsides of the fruits/vegetables, as well as the cut sections, for the prints.

- Create several pieces of Harvest Stamping art. Laminate them to make colorful placemats. Then give the placemats as gifts.

# Leaf Rubbings

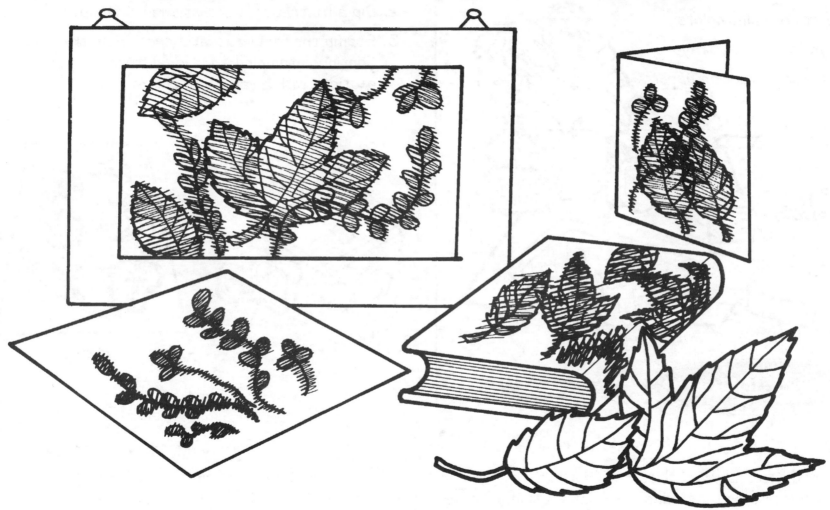

## Discovering Nature's Variety

# Leaf Rubbings

- Leaves of different shapes and sizes
- Thin paper, such as typing paper or newsprint drawing paper
- Crayons

1. Place the leaf on a table with the smooth side down.
2. Place the paper on top of the leaf.
3. Gently rub the side of a crayon back and forth across the paper to get the imprint of the leaf.
4. Continue the process, using different leaves and a variety of crayon colors.

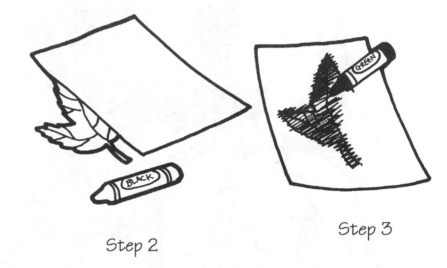

Step 2

Step 3

## MORE IDEAS

- Make an interesting fall collage by cutting out the leaf rubbings, poking holes in them, and hanging them from a stick.
- Make a construction paper frame to go around your rubbing design. Draw some more leaves on the frame.
- Make a variety of rubbings, using items such as coins, embossed greeting cards, paper clips, or textured cloth.
- Identify and label the different types of leaves used to create the rubbings. Linda Gamlin's **Trees** (Dorling Kindersley, 1993) and Herbert Spencer Zim's **Trees** (Golden Press, 1987) are excellent resources for this activity.

# Wrapped Pumpkin

An Apple in Disguise

# Wrapped Pumpkin

- Apple
- Orange tissue paper
- Green tissue paper
- Brown yarn
- Glue

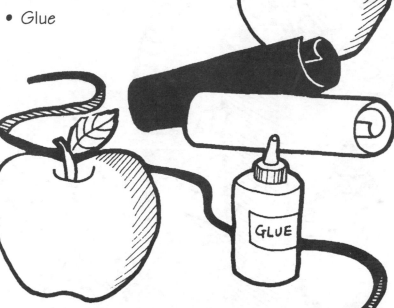

1. Cut a large square of orange tissue paper. Place the apple in the center of the square.

2. Wrap the orange tissue paper around the apple. Twist the paper at the stem, and trim the excess.

3. Cut a small square of green tissue paper. Poke the stem through the paper and twist upwards.

4. Coil the yarn around the stem. After a few coils, pull the yarn down over and around the apple. Continue coiling the yarn around the stem and wrapping it until the yarn looks like the lines on a pumpkin.

5. Glue the end of the yarn to the bottom of the apple.

Step 3

Step 4

**MORE IDEAS**

- Use felt to make jack-o'-lantern features.
- For an interesting family of jack-o'-lanterns, make some out of gourds.
- Wrapped Pumpkins look great in an autumn centerpiece surrounding a real pumpkin or jack-o'-lantern.

# Candy Bucket

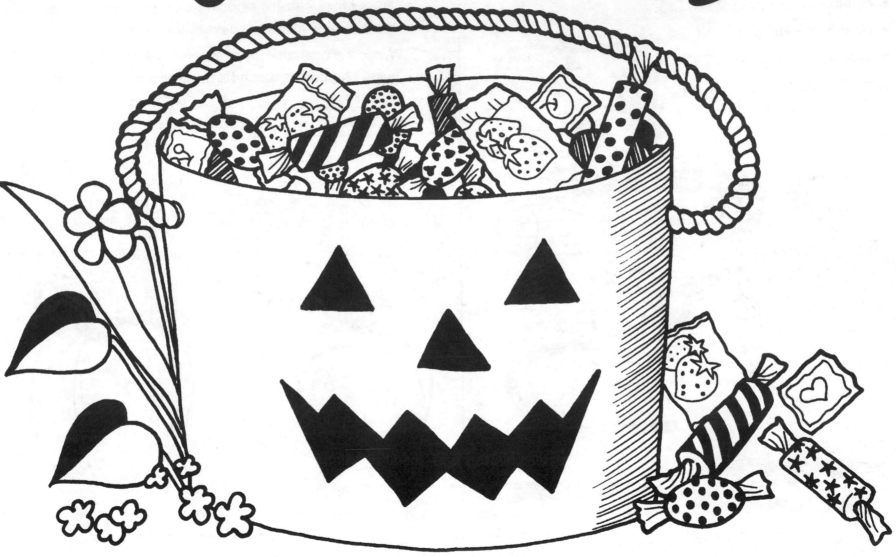

**Sweet Treats**

26

# Candy Bucket

## MATERIALS

- Cardboard ice cream cartons, half gallon (1.89 L) bucket shaped
- Orange construction paper, 8 1/2" x 11" (22 cm x 28 cm) sheet
- Black felt trimmings
- Scissors
- Glue
- Rope

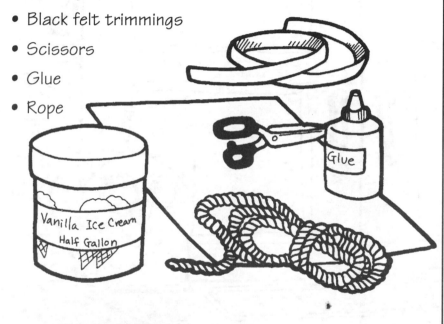

## LET'S DO IT!!

1. Remove the lid from the ice cream carton. Clean the carton and allow it to dry completely.
2. Wrap the outside of the carton with orange construction paper. Trim the excess. Glue the paper to the carton.
3. Cut pieces of felt to make the eyes, nose, and mouth of the jack-o'-lantern, and glue onto carton
4. Poke two holes in opposite sides at the top of the carton. Poke the ends of the rope through the holes. Then tie a knot in each end of the rope to use as a handle.

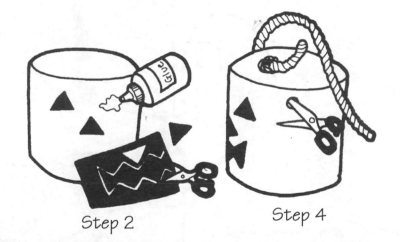

Step 2          Step 4

## MORE IDEAS

- Make a face on opposite sides of the jack-o'-lantern: one happy and one scary.
- Instead of the pumpkin design, decorate your bucket to go with your costume. For example, make a matching elephant bucket to go with the Elephant Jug Mask (page 32).
- During the spring, decorate some buckets for bouquets. As a centerpiece, fill the buckets with flowers, pinwheels, cornhusk dolls, or anything else that relates to a specific season.

# Stuffed Owl

**Friendly Owls Greet Halloween Visitors.**

# Stuffed Owl

- Brown paper bag
- Markers
- Old newspapers, shredded
- Stapler

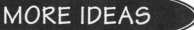

1. Open the paper bag, and draw an owl face and body on it.
2. Use markers to draw and color feathers on the bag.
3. Stuff the owl with shredded newspaper.
4. Staple the bag closed around the bottom.

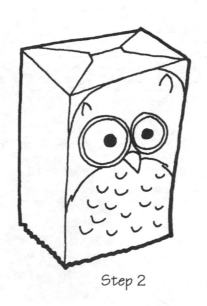

Step 2

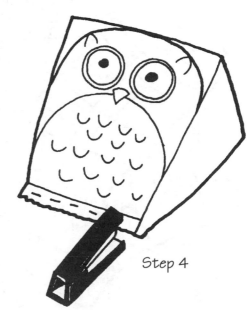

Step 4

## MORE IDEAS

- Use colored feathers to decorate the owl.

- Glue a branch to the bottom of the bag for the owl to sit on.

- Read **Good Night, Owl!** by Pat Hutchins (Macmillan, 1972). Can you make your paper bag owl wink?

- Make a number of stuffed owls, and put them in your windowsill on Halloween.

# Hand Print Spider

An Arachnid

# Hand Print Spider

- White construction paper
- Markers or crayons, various colors
- Assorted decorations, such as sequins and glitter (optional)

1. Place both hands, with thumbs together, on a piece of paper.
2. Have a partner trace around both hands.
3. Color and decorate the Hand Print Spider.

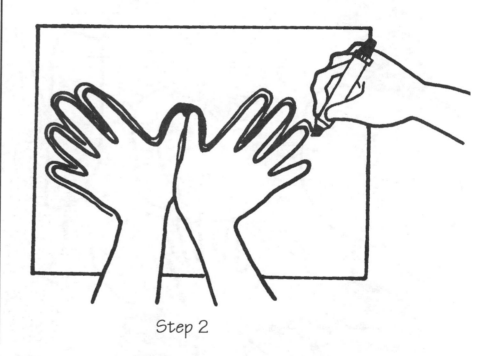

Step 2

## MORE IDEAS

- Use thread to create a web on and around the Hand Print Spider.
- Cut out Hand Print Spiders and hang them from the corners of ceilings and windows.
- Act out the rhymes "Itsy Bitsy Spider" and "Little Miss Muffet."
- Enjoy reading **Charlotte's Web** by E.B. White (HarperCollins, 1952).

# Elephant Jug Mask

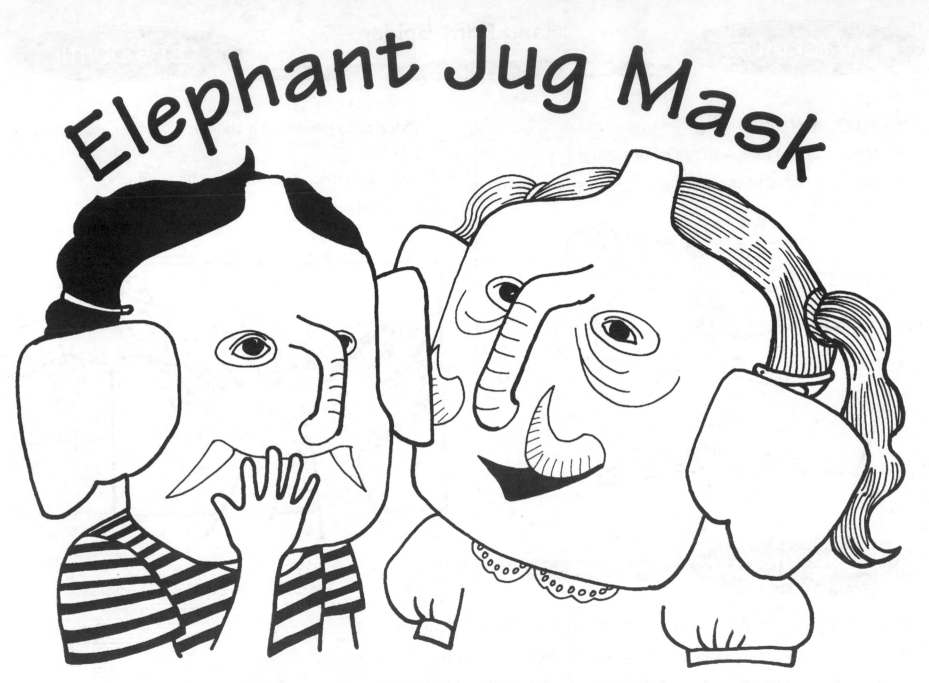

## Make a Trunk You Do Not Have to Pack.

# Elephant Jug Mask

- Clean, plastic one-gallon (3.79 L) milk jug
- Black crayon
- Scissors
- Black and white paint, mixed to make gray
- Styrofoam bowl or meat tray
- Paintbrush
- Elastic string
- Gray construction paper
- Stapler
- Knife

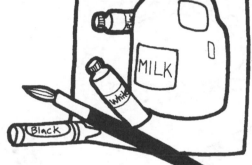

1. Cut the jug in half from top to bottom.

2. Hold the jug up to your face. The handle will be the elephant's trunk and should be placed over your nose. Use the crayon to mark the eye sockets. Cut out the eye sockets. Be sure they are big enough to see out of.

3. Paint the mask gray. Allow it to dry.

4. Carefully poke a small hole in the middle on each side of the jug. Tie the ends of an elastic string in the holes. The elastic should hold the mask in place on your face, without being too tight.

5. Cut two large ear shapes from gray paper. Staple the ears to the sides of the mask.

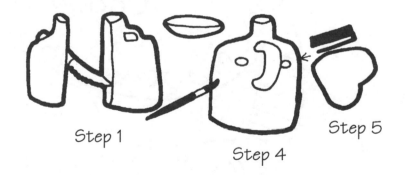

Step 1

Step 4

Step 5

## MORE IDEAS

- For the rest of an elephant costume, dress in gray sweat pants and shirt. Use a safety pin to attach a tail made from braided gray yarn.

- Try using the other half of the jug to create a different mask. Think of interesting ways to cut out the facial features or paint the mask silver to make an astronaut or alien costume.

# Masquerade Mask

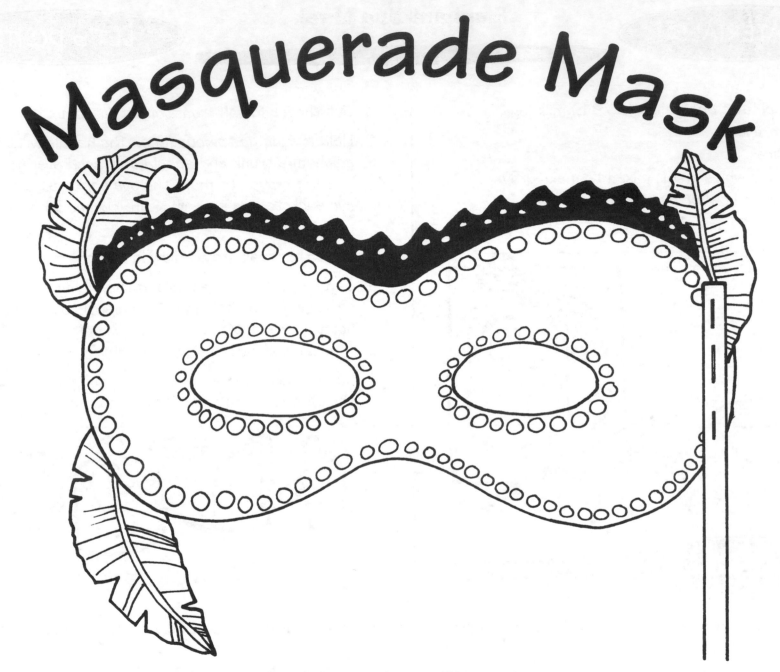

**The Mysterious Stranger**

34

# Masquerade Mask

- Tagboard
- Pencil
- Scissors
- Decorations, such as feathers, yarn, glitter, sequins, rickrack
- Glue
- Plastic drinking straw
- Stapler

1. Draw a large figure eight lengthwise on the tagboard.
2. Cut around the figure eight, leaving the center connected.
3. Cut out eye holes in the middle section of the figure eight.
4. Decorate the mask as desired.
5. On one side of the mask, staple the end of a straw to the back.

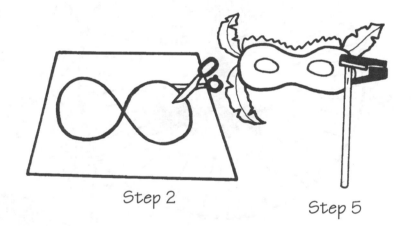

Step 2

Step 5

## MORE IDEAS

- Masks can be made out of almost any kind of box or container. Try cutting a plastic jug in half from top to bottom. Cut eye holes and paint your jug mask to make any real or imagined creature.

- If you don't want to hold onto the mask with the straw, staple the ends of an elastic string to the inside of each side.

- Learn how to do some magic tricks. Wear the Masquerade Mask as you perform these feats of magic for your family or friends.

# Jack-O'-Lantern Wreath

Halloween, or All Hallow's Eve, Is Celebrated on October 31.

# Jack-O'-Lantern Wreath

## MATERIALS

- Cardboard doughnut shape, about 8" (20 cm) in diameter
- Orange yarn
- Scissors
- Black construction paper scraps
- Tape

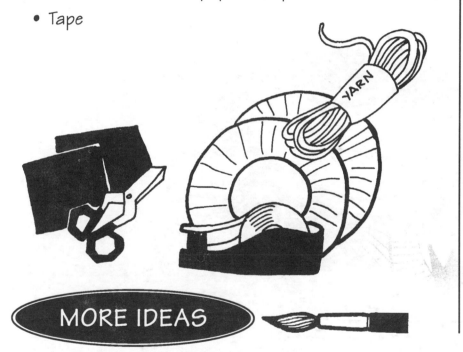

## LET'S DO IT!!

1. Wrap the yarn one time around the cardboard doughnut and secure the end with a knot.

2. Continue wrapping the yarn through the hole and around the cardboard to cover all of the doughnut.

3. After the cardboard is completely covered, secure the loose end of the yarn by tying it to the wrapped yarn. Trim any excess.

4. Use the scraps of black construction paper to cut out two eyes, a nose, and a mouth.

5. Tape each facial feature to a single piece of yarn. Tie the loose ends of the yarn to the top of the doughnut, so the features hang down in the hole of the doughnut shape.

Step 2

Step 5

## MORE IDEAS

- To make wrapping the yarn through the hole of the doughnut shape easier, take one end from the skein and wrap it around a craft stick. Continue wrapping the stick until it is fat with yarn. The stick will go through the hole easier than an entire skein.

- Cut yarn in different fall colors and different lengths. Tie the ends together and wrap them around the wreath to give it a variegated yarn look. Use additional yarn or glue to attach real or imitation fall leaves.

# Pine Cone Turkey

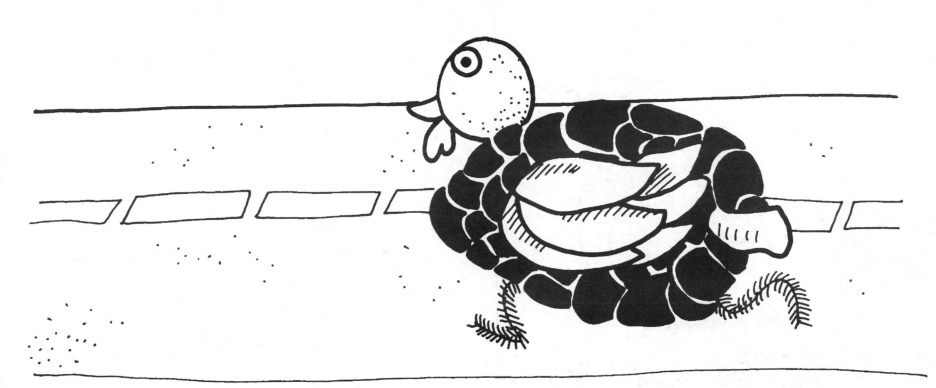

**Riddle: Why Did the Turkey Cross the Road?**

**Answer: To Get to the Other Side, Of Course!**

# Pine Cone Turkey

- Pine cone
- Construction paper, various colors
- Glue
- Styrofoam ball
- Felt scraps
- Red pipe cleaners
- Brown paint and paint brush

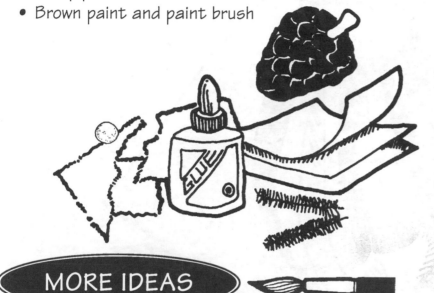

## MORE IDEAS

1. Cut out several feather shapes from colored construction paper. Insert and glue the feathers close to the large end of the pine cone.

2. Paint the Styrofoam ball brown. When the paint is dry, glue the ball to the small end of the pine cone.

3. Cut out facial features from the felt scraps. Glue the facial features onto the ball. Cut and bend a small piece of red pipe cleaner to make a wattle. Stick the wattle into the bottom of the ball.

4. Bend two pipe cleaners to look like turkey feet. Glue the feet onto the pine cone turkey.

Step 1          Step 4

- Purchase real colored feathers from a local craft store. Use those instead of construction paper feathers.

- If you would like to have an edible turkey, use an apple for the body. Use toothpicks to attach a caramel for the head, a raisin for the wattle, and cranberries alternated with mini marshmallows for the feathers. Be sure to remove the toothpicks before eating the turkey.

- For Easter, make bunnies by spray painting the pine cones pink or white and then adding paper ears and pompons for the tails.

# Cornucopia

**"Horn of Plenty"**

# Cornucopia

- 8" x 8" (20 cm x 20 cm) brown construction paper (makes 4)
- Scissors
- Stapler
- Popcorn
- Small fruits, nuts, or candies (optional)

1. Cut a large circle from the construction paper.

2. Cut the circle into quarters.

3. Form a cone shape with each quarter of the circle. Staple each cone shape to hold it in place.

4. Fill each cone shape with popcorn, small fruits and nuts, or small candies.

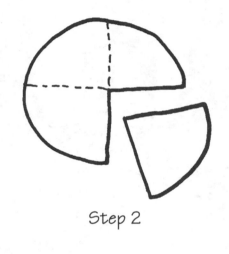

Step 2

Step 3

## MORE IDEAS

- Use your cornucopias as place cards by printing the name of a guest or family member on each one. Decorate with glitter, lace, stickers, and ribbons. Fill with popcorn, small fruits and nuts, candy corn or other small candies, or real miniature pumpkins.

- Use a large piece of paper to create cornucopias that can be used as table centerpieces. Place real fruits, vegetables, and nuts in each centerpiece. Give the centerpieces away as gifts.

- For Christmas, punch a hole in one end of each cone shape and make a loop with a piece of string. Hang the cone shapes as ornaments on your Christmas tree.

# Pilgrim and Indian Finger Puppets

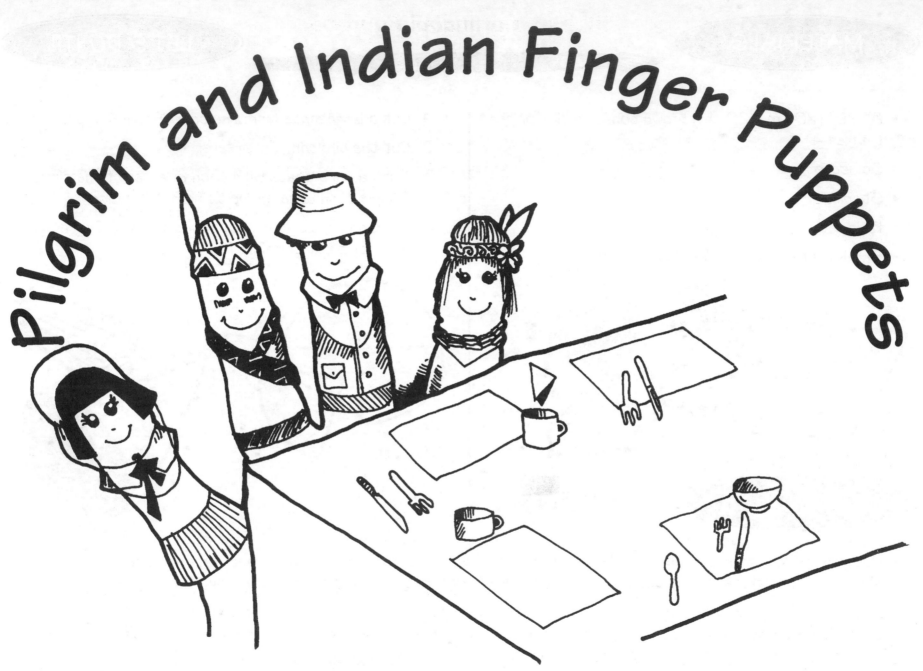

Friends in the New World

# Pilgrim and Indian Puppets

## MATERIALS

- Washable markers
- Scissors
- Tape
- White tissue paper
- Scraps of black construction paper

## LET'S DO IT!!

1. Use the washable markers to draw facial features directly onto your fingers.

2. To create an Indian, draw colored headbands; to create a Pilgrim woman, draw a collar, wrap and tape a small piece of white tissue paper over the tip of the finger to make a hat, and cut and tape a small rectangular piece of tissue paper around the second knuckle for an apron; to create a Pilgrim man, cut and tape a tiny hat made from black construction paper on the tip of the finger.

Step 1

## MORE IDEAS

- Make a set of Pilgrims on one hand and a set of Indians on the other hand. Then, use the puppets to role play a friendly conversation among the Pilgrims and Indians.

- Do research to find what the traditional clothing of some Native Americans looked like. Some wore elaborate head dresses; some wore no feathers at all; others had symbolic face paintings. You may add some of these features to your puppets if you desire.

- Learn about the Pilgrim's first Thanksgiving by reading one or more of the following books: Joan Anderson's **The First Thanksgiving Feast** (Houghton Mifflin, 1984), Linda Hayward's **The First Thanksgiving** (Random House, 1990), Jean Craighead George's **The First Thanksgiving** (G.P. Putnam's Sons, 1993).

# Pilgrim Hat Place Cards

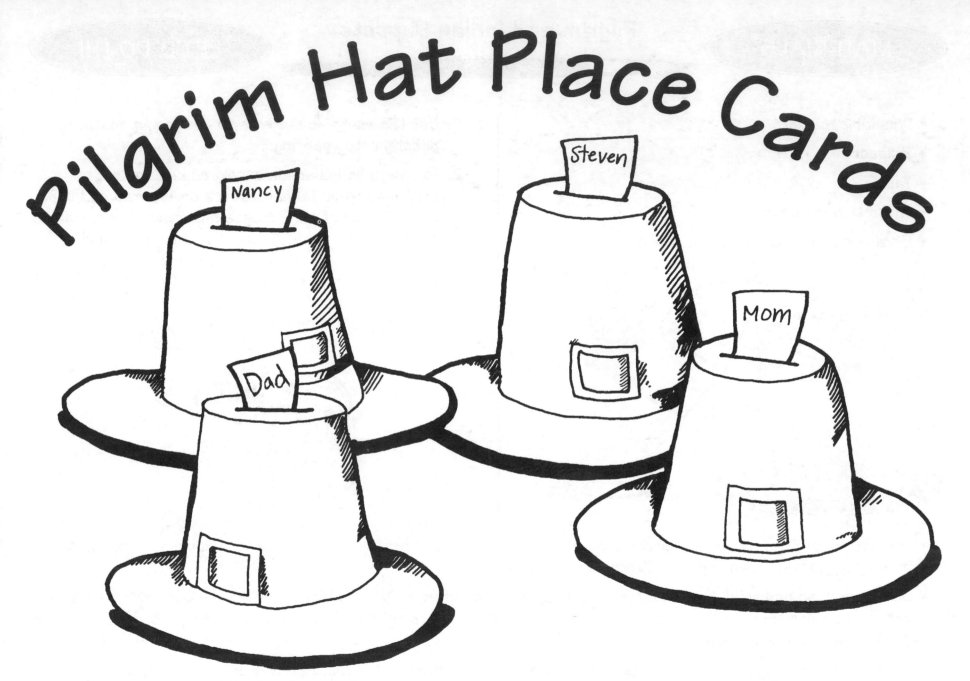

In 1620, the Pilgrims Founded the Colony of Plymouth.

# Pilgrim Hat Place Cards

- Styrofoam cups, one for each place card
- Black paint
- Paintbrush
- Black, yellow, and white construction paper
- Pencil
- Scissors
- Glue
- Colored pens or markers (optional)
- Craft Knife

1. Use black paint to cover the outside of the cups, including the bottom. Allow the paint to dry.

2. For each cup, draw a circle on the black construction paper that is larger than the top of the cup.

3. Glue the circles onto the open end of cups. Turn the cups over so they are resting on the black circles.

4. For each cup, cut a square belt buckle shape from the yellow construction paper. Glue the buckle just above the black circle.

5. Place the hats so that the buckles are facing you. Use the Craft Knife to carefully make a slit from side to side across the top of each hat. Write a name on white construction paper strips and place them in the top of the hats.

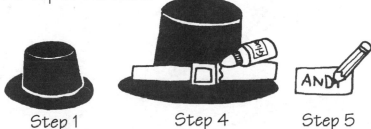

Step 1        Step 4        Step 5

## MORE IDEAS

- Make extra hats to use as part of a Thanksgiving centerpiece. Place them among Indian corn (maize), gourds, and colorful fall leaves.

- Instead of using name cards, names can be written directly onto the hats using yellow fabric paint.

- Cut out the top of the hat and fill it with special treats like popcorn or candy corn.

- You can make green leprechaun hats for place cards to be used on St. Patrick's Day.

# Hand Print Turkey

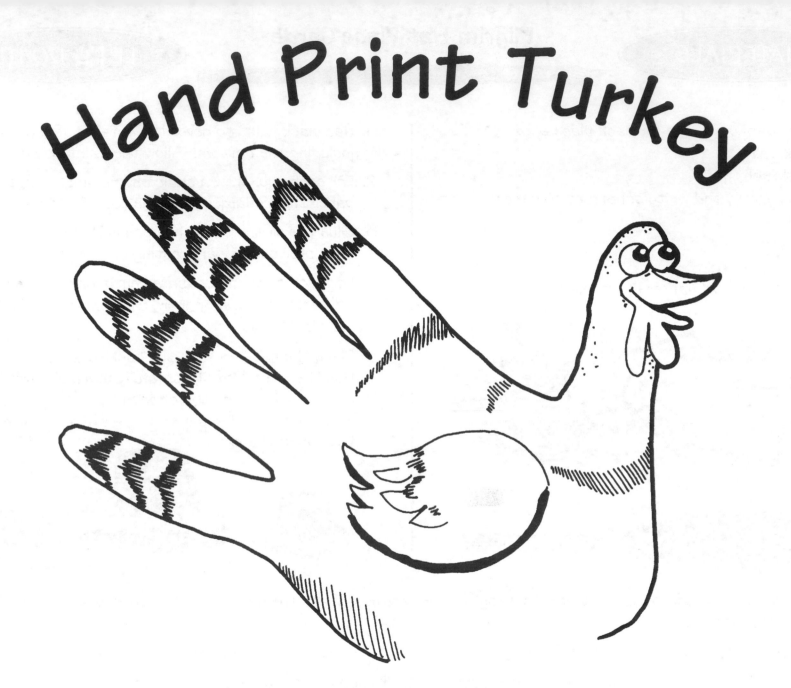

Gobble, Gobble. It's Turkey Time!

# Hand Print Turkey

## MATERIALS

- White construction paper
- Paintbrushes
- Brown, orange, red, and yellow paints
- Black and red markers

## LET'S DO IT

1. Paint the palm of a hand and the thumb brown.
2. Paint the fingers different colors.
3. Press the hand onto a sheet of white construction paper.
4. After the paint is dry, draw a wattle with the red marker and an eye with the black marker.

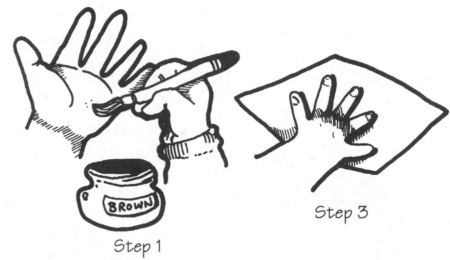

Step 1

Step 3

## MORE IDEAS

- Hand Print Turkeys are a Thanksgiving tradition. Another way to make them is by placing a hand face down on brown paper and outlining it. Then glue a colored feather over the outline of each finger.

- Another hand print turkey figure can be done with a front-facing perspective. Paint all eight fingers with brown paint. Place one palm on the back of the other hand. Press all your fingers onto the white construction paper, producing eight feathers. Cut a brown circle for the body. Glue it onto the white paper so that the feathers emerge from behind. Cut an orange circle for the head. Glue it to the body. Draw two eyes, a nose, and a mouth on the orange circle.

- You may wish to use paints, crayons, or markers to add a background for the Hand Print Turkey.

# Winter Poem

by Lori Racliffe

Bare branches stretch to a winter sky,
Snowflakes dance, swirl, and flutter on by.
Skaters glide over the frozen rink,
Snowmen stand guard with a knowing wink.

Wet soggy mittens and cold stiff toes,
Merry eyes shine and rosy cheeks glow.
Inside a fire makes it warm and snug,
Piping hot chocolate waits in a mug.

After singing the carols, the children can't sleep,
Packages lay opened, wrapping paper in heaps.
Hanukkah candles in the window so bright,
A babe in a manger on a cold still night.

# Mini Gingerbread House

- Small milk carton, cleaned and dried
- Can of white frosting
- Graham crackers
- Blunt knife
- Colored icing in a tube
- Assorted candies for decorating

1. Break the graham crackers so that you have four pieces that are large enough to cover the sides of the milk carton and two pieces that are large enough to cover the top surfaces.

2. Frost the "walls" and "roof" pieces and place those pieces against the sides and surfaces of the carton.

3. Fill the cracks between the graham crackers with frosting. Apply extra frosting to roof to create snow.

4. Use the colored icing in a tube to draw a door and some windows.

5. Decorate the Mini Gingerbread House with candies.

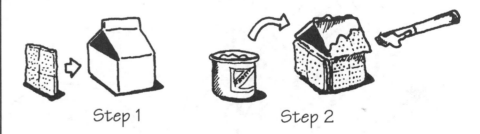

Step 1          Step 2

## MORE IDEAS

- Put the house in the lid of a box and create a winter scene around it. The scene may include snowmen made from marshmallows, trees made from pretzels, and a lollipop pond. Place some coconut inside the box lid to make snow on the ground, and sprinkle powdered sugar over the top of the scene for fallen snow.

- Make a village of graham cracker houses and businesses, using boxes of different sizes. Using orange juice cans and small milk cartons, you can make graham cracker and pretzel stores, churches, apartment buildings, etc.

- Visit a bakery to see different kinds of gingerbread houses.

# Winter Bird Feeder

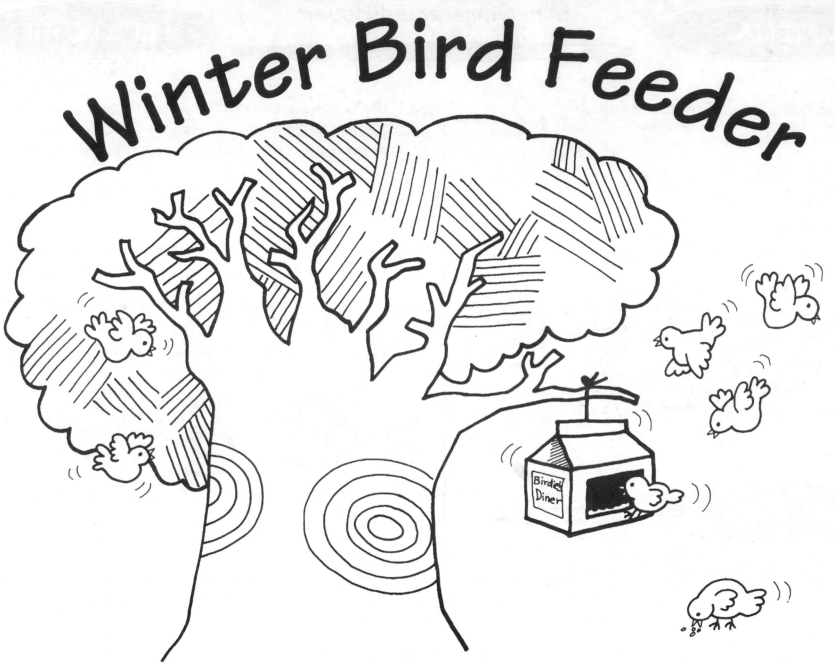

## A Restaurant for Birds

# Winter Bird Feeder

- Small milk carton, cleaned and dried
- Scissors
- Paint, any color
- Paintbrush
- String
- Birdseed

1. Cut out the top half of the panels on opposite sides of the milk carton.

2. Paint the carton. Allow the paint to dry.

3. Poke a hole in the top of the milk carton and tie a loop of string through the hole.

4. Fill the bottom of the carton with birdseed. Hang the feeder in a tree.

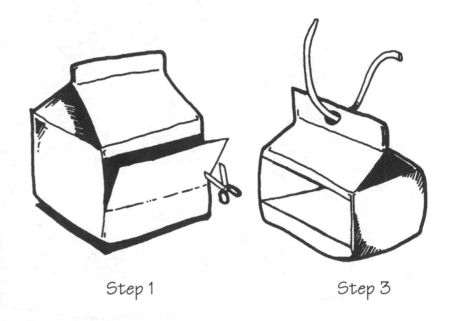

Step 1

Step 3

## MORE IDEAS

- Another easy birdfeeder is made from a piece of day-old bread that is cut with a cookie cutter. Cover both sides of the bread with peanut butter and birdseed. Poke a hole in the bread and hang it up with a loop of string.

- Pine cones covered with peanut butter and birdseed also make attractive birdfeeders hanging from a tree.

- Make all three types of feeders described on this page and see which one the birds like best!

# Plastic Snowflake

**No Two Snowflakes Are Exactly Alike.**

# Plastic Snowflake

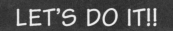

- Plastic berry basket
- Scissors
- Glue
- Wax paper
- Glitter

MORE IDEAS

1. Cut a circular shape from the bottom of the plastic berry basket.

2. Place the circular shape on a sheet of wax paper.

3. Cover the circular shape with glue. Sprinkle glitter on the glue.

4. Allow the glue to dry. Carefully shake off any excess glitter. Save and reuse the glitter that remains on the wax paper.

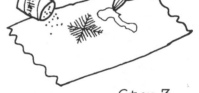

Step 1                              Step 3

- Experiment by cutting different shapes from the bottom of the plastic berry basket. Cover each side of the different shapes with glue and glitter. Then, use pieces of thread to hang the Plastic Snowflakes in a window.

- Use the snowflakes as a template for printing snowflake designs. Dip the snowflake in paint and press it onto paper. Different baskets have different designs, so you will have an assortment of snowflakes if you use multiple baskets.

- Use the plastic snowflake pattern as a stencil. Place two or three snowflake stencils on white paper and use black spray paint to cover the paper. Allow the paint to dry. When you remove the snowflake stencils, they will appear white on a black background, looking like snowflakes at night.

- If you live in an area where you have real snowflakes, freeze a piece of black construction paper. Then take the paper outside, and catch snowflakes as they fall. Look at them through a magnifying glass to see how each one is unique.

# Ice Sculptures

Art Made From Ice

54

# Ice Sculptures

- Freezer
- Water
- Food coloring, various colors
- Odd-shaped containers, such as pie pans, bottle caps, cups, plastic bags, rubber gloves, square and round shaped plastic containers
- Rubber bands
- Blunt knife or screwdriver

1. Fill each of the containers with water. Add food coloring to dye the water different colors.

2. Place the containers in the freezer overnight or until the water has frozen.

3. Use warm water to remove the ice from the containers.

4. Now, build and create. Carefully carve a variety of designs, using a blunt knife or screwdriver. Connect different blocks of ice with rubber bands.

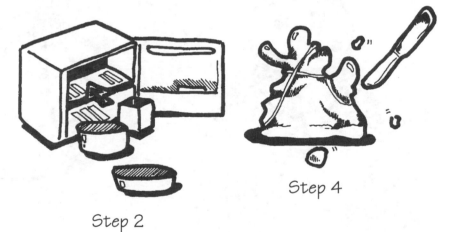

Step 2

Step 4

## MORE IDEAS

- Make snow cones by chipping off bits of ice from your sculpture. Place the ice chips in a cone and add some fruit juice for flavoring.
- Use everyday rectangular ice cubes as "bricks." Have an ice cube stacking contest.
- If icicles are available where you live, use them as part of your sculpture.
- A more permanent sculpture resembling ice can be made from sugar cubes.

# Soapy Snowman

## Soap Flakes Become Snowflakes

# Soapy Snowman

- 1 cup (250 mL) soap flakes
- 2 tablespoon (30 mL) water
- Bowl
- Cloves
- Toothpicks

1. Measure and pour the soap flakes into a bowl. Use your hands to mix the water with the soap flakes.

2. Make two ball shapes, one large and one small, from the soap flakes.

3. When the soap balls are firm, use toothpicks to connect them into a snowman shape.

4. Poke cloves into the small soap ball to make the eyes and mouth of the snowman.

5. Poke some cloves into the large soap ball to make buttons down the front.

Step 2

Step 3

**MORE IDEAS**

- In the mixing stage, add a couple of drops of food coloring to make snowballs or snowmen of different colors.
- Double the recipe to make a larger snowman as a centerpiece for your table.
- Use scraps of construction paper or fabric to make clothing, such as a hat, scarf, and mittens, for the snowman.

# Matryoshka Dolls

## MATERIALS

- Three paper cups: small, medium, and large
- Fabric paints
- Paintbrushes

## LET'S DO IT!!

1. Turn each cup upside down.

2. Paint the same Christmas-related object, such as a tree, a bell, or a present, on all three cups. Your design of the object you choose can vary slightly from cup to cup. For example, if you paint Christmas trees on the cups, each tree can have different types of ornaments on it.

3. After allowing the paint to dry, place the cups one on top of the other.

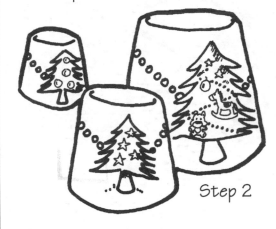

Step 2

Step 3

## MORE IDEAS

- Invite a friend or family member to remove one cup at a time until all three are revealed.

- Use a collage effect by designing the objects on the cups with pieces of fabric, construction paper, or wallpaper.

- Try to make the three objects different but related. Examples: Santa, a reindeer, and a sled; a tree, an ornament, and a string of light bulbs; a Menorah (candelabrum), Hanukkah gelt (gold coins), and a dreidel (top).

- Use several boxes that fit one inside the other to create a more elaborate set of Matryoshka Dolls.

# Lacy Angel

- Small paper doily
- Large paper doily
- White construction paper
- Glue
- Small white pipe cleaner
- Tape

1. Fold a large paper doily in half and shape it into a cone. Use glue to hold the cone in place.

2. Create the angel's wings by folding a small paper doily in half and gluing the center of it to the back of the cone.

3. Cut a small circle from the white construction paper for the angel's face. Glue the circle to the point of the cone. You may wish to add facial features to the circle.

4. Shape a pipe cleaner to form the angel's halo. Tape the pipe cleaner to the back of the circle and cone.

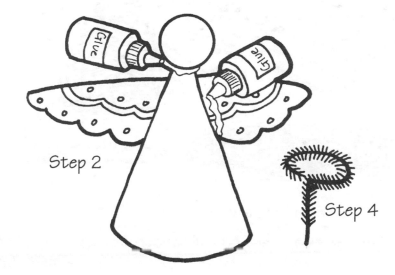

Step 2

Step 4

**MORE IDEAS**

- Accent the angel with glue and glitter.
- Set your Lacy Angel in a cloud made from cotton batting.
- Read *The Littlest Angel* by Charles Tazewell (Children's Press, 1962).

# Simple 3-D Star

- Yellow construction paper
- Pencil
- Scissors
- Hole punch
- Yarn

1. Draw and cut two identical star shapes.

2. Make a slit from the top to the middle of one star. Make a slit from the bottom to the middle of the other star.

3. Slide the stars together at the slits.

4. Punch a hole in the point of one star. Use yarn to hang the Simple 3-D Star from the ceiling.

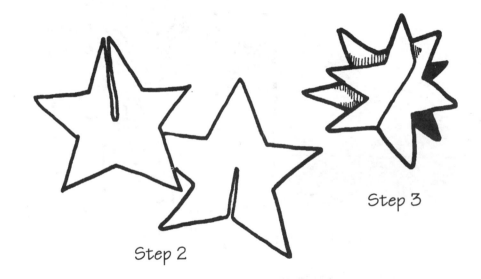

Step 3

Step 2

## MORE IDEAS

- Decorate the star with glitter.

- Cut the two stars out of construction paper. Then cover them with tin foil before putting them together to create a shiny Simple 3-D Star. Use this for a sparkly Christmas tree topper.

- This three-dimensional effect can be created using any simple shape including a Christmas tree, dreidel, egg, Star of David, and Pilgrim hat.

- Make a number of Simple 3-D Stars in various sizes to hang from the ceiling during any season.

# Fabric Ball Ornament

- Fabric scraps, cut into small pieces
- Small Styrofoam ball
- Pencil with a sharp point
- Fabric glue
- Ribbon

1. Place a small piece of fabric on a Styrofoam ball. Use a sharp pencil point to carefully push the edges of the fabric into the Styrofoam.

2. Repeat Step 1 with additional fabric scraps until the ball is completely covered. If necessary, use glue to hold the fabric onto the ball.

3. Loop a piece of ribbon and attach it to the ball using fabric glue. Allow the glue to dry. Then hang the ornament by the ribbon loop.

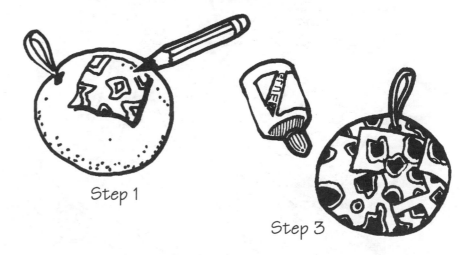

Step 1

Step 3

## MORE IDEAS

- Make a small bow from one of the fabrics and glue it onto the base of the ribbon.

- For Easter, get oval Styrofoam balls and use spring colored and decorated fabrics to make Fabric Egg Ornaments as centerpieces.

- Make several Fabric Ball Ornaments, using a variety of holiday colored and decorated fabrics. Use string and a wire hanger to create a mobile with these ornaments. Hang the mobile from the ceiling.

# Craft Stick Reindeer

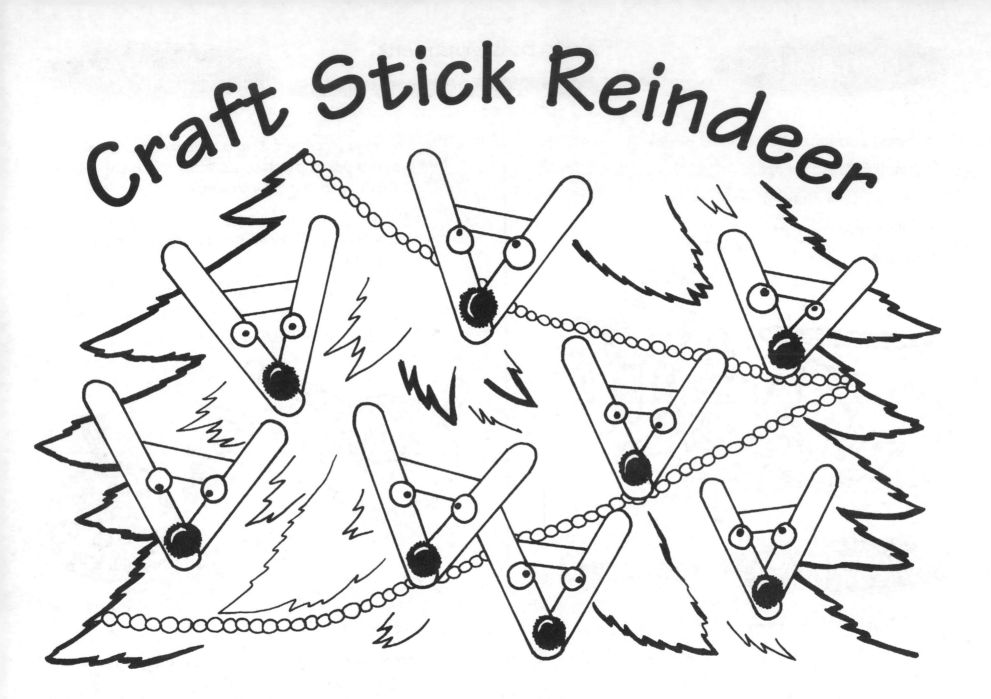

## Santa's Eight Tiny Reindeer

# Craft Stick Reindeer

- 2 ½ craft sticks
- Brown paint
- Paintbrush
- Small red pompon
- 2 plastic wiggly eyes
- Glue

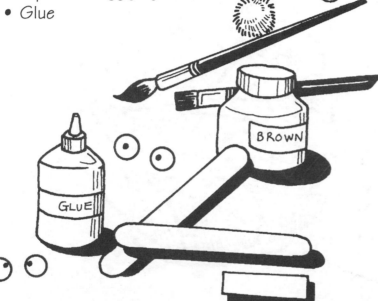

1. Paint the craft sticks brown.

2. Glue the two long sticks together to make a V.

3. Glue on the half stick to make upside down A.

4. Glue on the two wiggly eyes and the pompon for the nose.

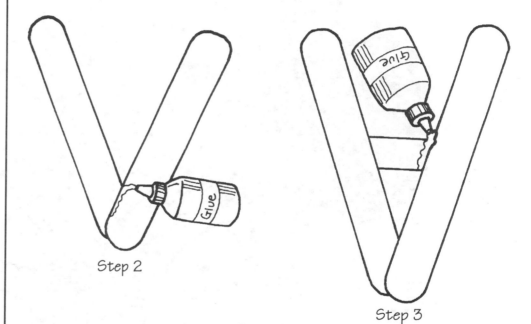

Step 2

Step 3

## MORE IDEAS

- Instead of using craft sticks, make the reindeer antlers from small twigs.
- Hang the Craft Stick Reindeer by tying brown yarn where the sticks meet and tie a bow at the top.
- If you would like your Craft Stick Reindeer to have a body, cut an oval and two short legs (one in front and one in back) from a brown paper bag or brown construction paper.

# Mini Christmas Tree

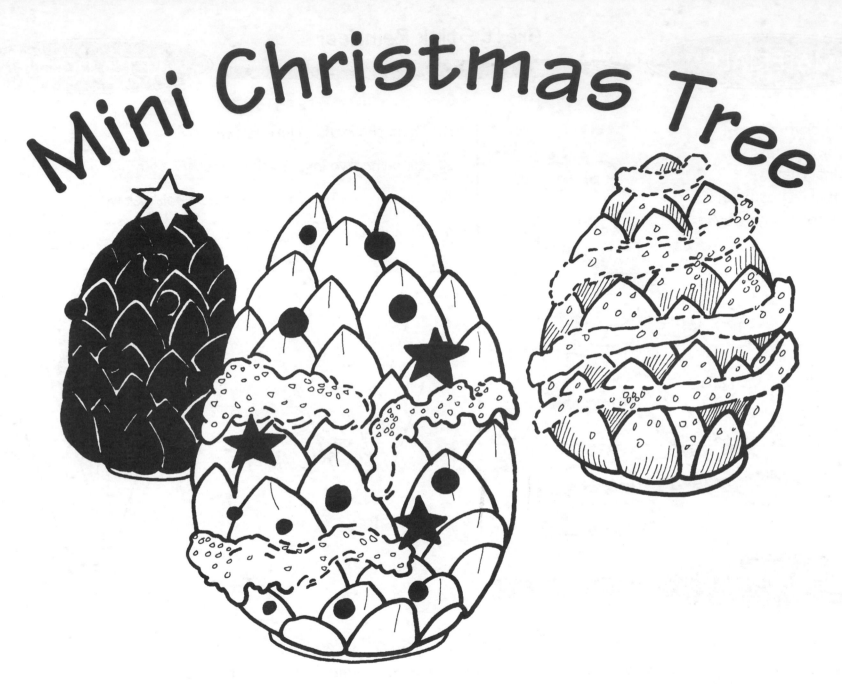

## Finally, a Christmas Tree You Do Not Have to Chop Down!

# Mini Christmas Tree

- Newspaper
- Pine cone
- Green spray paint
- Glue
- Glitter

1. Spread out the newspapers to cover your work area in a well-ventilated room. Place the pine cone on the newspapers. Cover the entire pine cone with green spray paint.

2. After the paint is completely dry, drizzle glue over the top of the pine cone.

3. Sprinkle glitter on the wet glue. Allow the glue to dry.

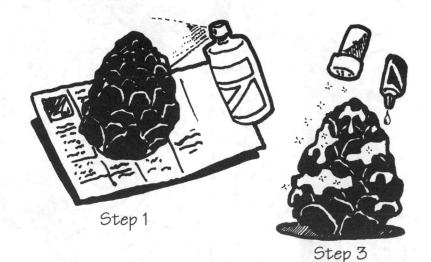

Step 1

Step 3

## MORE IDEAS

- Punch colored confetti and glue it on as tiny decorations; or make some popcorn, string it on a piece of thread, and wind it around your Mini Christmas Tree.

- Make a mini Simple 3-D Star (page 60) to put on top of your Mini Christmas Tree.

- If you have access to a large number of pine cones, collect 20 or more. Use yellow or gold spray paint on one pine cone. Cover all the other pine cones with green spray paint. To make a larger Mini Christmas Tree, arrange the green pine cones so they make a large upside-down cone shape. Place the yellow or gold pine cone at the top as the star. Use hot glue to keep the pine cones together.

# Gift Wrap

Wrap It Up!

66

# Gift Wrap

## MATERIALS

- Toilet paper tube
- String
- Scissors
- Tape
- Red and green paint
- Paints, assorted colors (optional)
- Paper or Styrofoam plates or meat trays
- Paper grocery bag, large

## MORE IDEAS

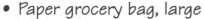

## LET'S DO IT!!

1. Cut the string and randomly coil it around the toilet paper tube. Use tape to attach the ends of the string to the inside of the tube.

2. Pour red and green paint on separate paper or Styrofoam plates. Roll the tube in the paint.

3. Roll the tube onto a rectangular piece of paper cut from a large grocery bag.

4. Allow the paint to dry. Roll the tube in additional colors as desired.

5. After all the paint has dried, use the paper to wrap gifts for friends or family members.

Step 3

- Make gift cards to match the wrapping paper. Remove the painted string from the toilet paper roll. Then use pieces of the string to attach the cards to the gifts.

- Using a small paint roller to roll the colors onto the piece of grocery bag, create your own designer plaid wrapping paper.

- Add to the painted design on the wrapping paper by using stencils to draw on Christmas/holiday items, such as Santa hats, wreaths, trees, and stars.

# Hand Print Wreath

## A Circle of Hands

# Hand Print Wreath

- Green and red construction paper
- Paper plate
- Pencil
- Scissors
- Glue
- Yarn or ribbon

## MORE IDEAS

1. Cut out the center of the paper plate and discard.

2. Trace and cut out numerous hand prints from the green paper. Glue these hand prints around the paper plate with fingers pointing away from the center.

3. Cut small red circles from the red paper to represent berries. Glue the red berries onto the green paper hands as desired.

4. Carefully poke a hole in the top of the wreath and hang it with a piece of yarn.

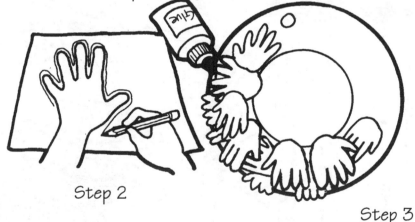

Step 2

Step 3

- Trace, cut out, and layer numerous hand prints of different sizes to create a three-dimensional effect.

- Add a red crepe paper bow to the wreath.

- Instead of cutting circles from red paper for the berries, use red pompons.

- Another way to make the hand prints is to dip your hands in green paint, press your hands on pieces of paper, and cut out the hand prints to make the wreath.

# Santa Finger Puppets

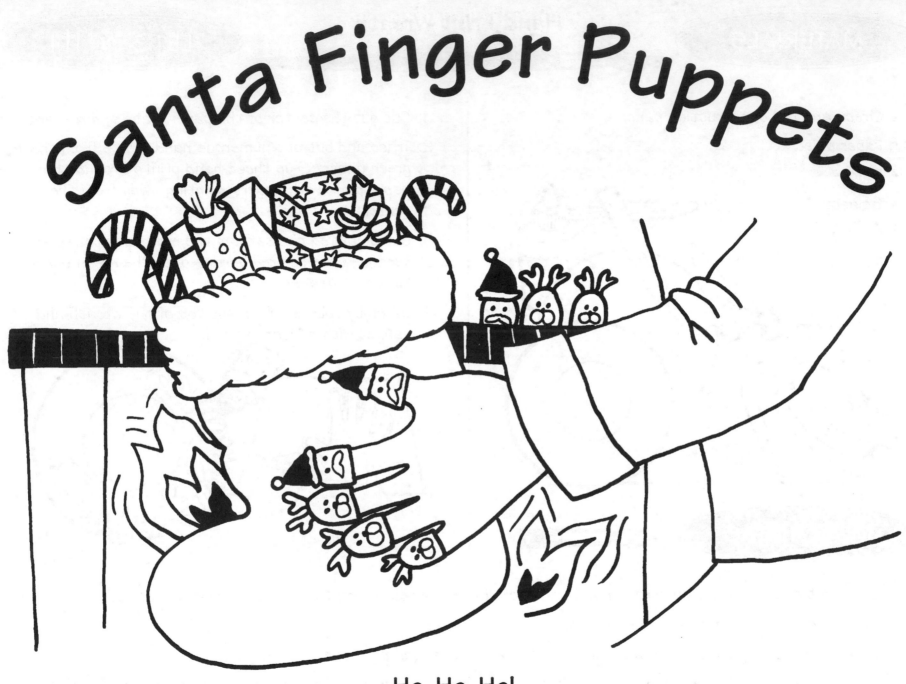

Ho, Ho, Ho!

# Santa Finger Puppets

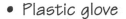

- Plastic glove
- Red felt
- Scissors
- Fabric glue
- Cotton
- Black permanent marker

1. Cut the fingers off of a plastic glove, one glove finger for each finger puppet.

2. Make a cone hat for Santa, using a half circle of red felt.

3. Make a suit for Santa, using a rectangle of red felt.

4. Cut pieces of cotton to add as a beard and trimming for the clothes.

5. Glue all the pieces to a glove finger.

6. Use the black permanent marker to draw on facial features.

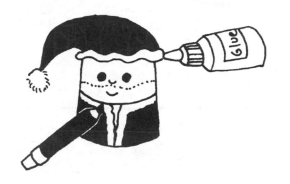

## MORE IDEAS

- If you make more than one Santa Finger Puppet, you can give them away to friends.

- If you do not have felt, use red construction paper.

- Create an entire Santa's workshop with a Santa Finger Puppet and four finger puppets that are green-trimmed elves.

- Make a finger puppet reindeer with small twigs for antlers, wiggly eyes, and a tiny red pompon as the nose.

# St. Lucia Wreath

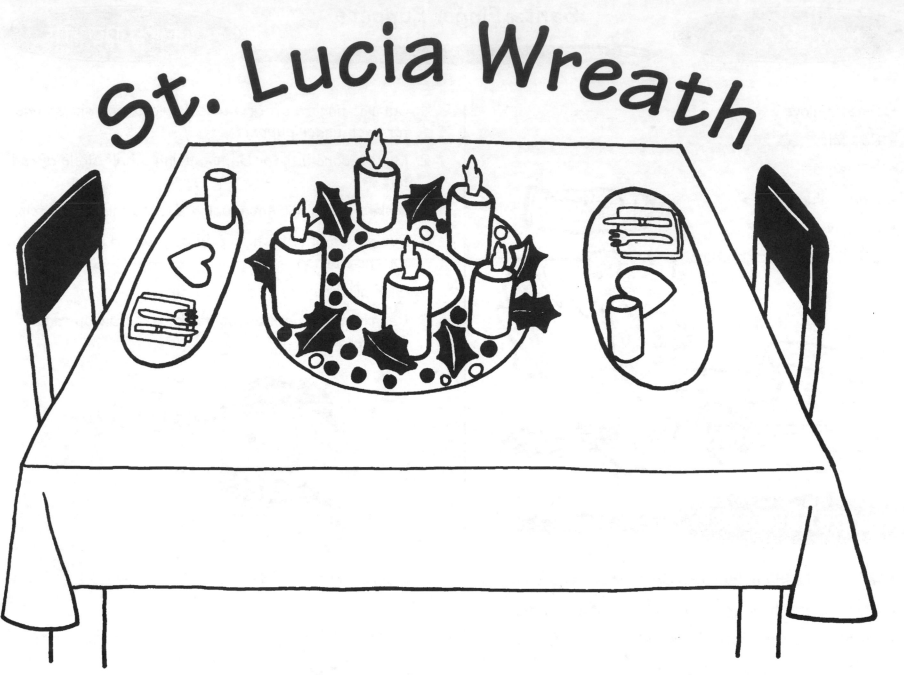

St. Lucia's Day Is Celebrated in Sweden on December 13.

# St. Lucia Wreath

- 12" x 12" (30 cm x 30 cm) green poster board
- Five toilet paper tubes
- Scissors
- White, green, and red construction paper
- Yellow tissue paper
- Glue

## MORE IDEAS

1. Cut a large wreath shape from the poster board.
2. Cover the toilet paper tubes with white paper construction paper. Cut five 1" (2.5 cm) slits in one end of each tube.
3. Cut squares of yellow tissue paper. Stuff the slits in the tubes with the squares of yellow tissue sticking out. These will represent candles.
4. Glue the candles around the poster board wreath so they are evenly distributed.
5. Cut out holly-shaped leaves from the green construction paper and small circles from the red construction paper to be berries.
6. Surround the candles on the wreath with the holly and berries.

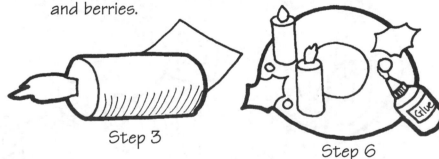

Step 3

Step 6

- In addition to holly and berries, cut and glue poinsettia-shaped leaves from red construction paper for more Christmas color.

- You can make these wreaths into hats by measuring the head circumference and cutting the hole in the poster board to match.

- Make authentic-looking wreaths by poking live greenery and pine cones into a Styrofoam wreath shape. Glue real candles to your wreath, but do not light them.

# Farolito

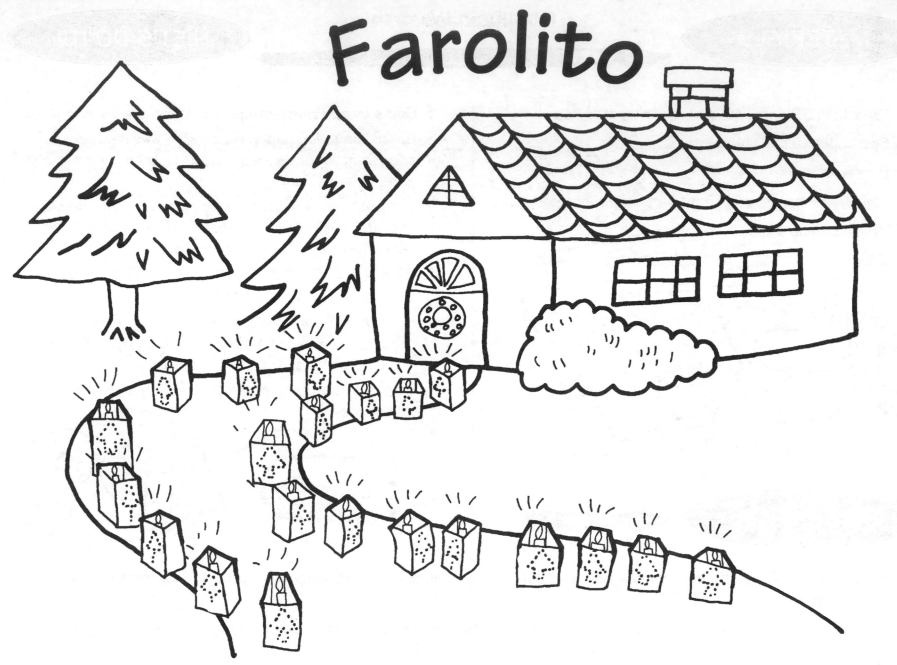

**Light the Way.**

# Farolito

- Paper lunch bag
- Pencil
- Hole punch
- Sand
- Votive candle
- Matches or lighter, for adult use only

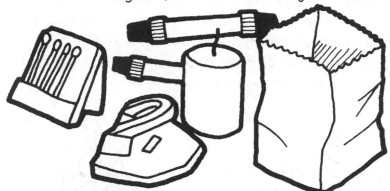

1. Fold a paper lunch bag in half lengthwise.
2. Draw half of a tree pattern on the bag. Punch evenly-spaced holes on the tree pattern.
3. Open the bag and fill it with 1" (2.5 cm) of sand.
4. Place the candle inside the bag and press the bottom of it into the sand.
5. Have an adult carefully light the candle.

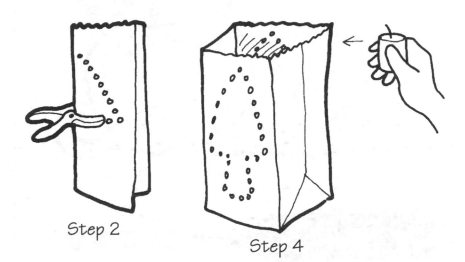

Step 2

Step 4

## MORE IDEAS

- Farolitos look beautiful lining a driveway or walkway. Alternate red and green bags to add to the festive appearance.

- There are many different shapes of hole punches available from craft stores. For variety, choose yellow bags, draw star shapes on each, and make the holes with a star-shaped hole punch.

- Farolitos can also be made out of recycled tin cans. Carefully poke holes with a nail to create your design. Then, pour sand into the decorated can and set the votive candle in the sand.

# Apple Pomander Ball

- Apple
- Whole cloves
- Cinnamon
- Large resealable plastic bag (large enough for the apple)
- Ribbon or wide yarn

**MORE IDEAS**

1. Hold the round part of a clove and stick the stem into the apple.

2. Continue sticking cloves into the apple until it is completely covered.

3. Pour some cinnamon into a resealable plastic bag. Put the apple into the bag. Seal and shake the bag.

4. Remove the apple from the bag. Tie two pieces of ribbon or wide yarn around the apple so that they criss-cross at the bottom and knot at the top. Then, tie a third piece of ribbon or yarn to the top of the apple so that you can hang it in up.

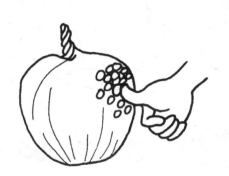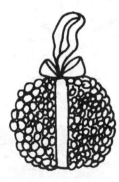

- Make a Apple Pomander Ball and place it in a bag made from fabric. Use it like a sachet and place the bag in a dresser drawer or closet.

- Make a variety of Pomander Balls using different pieces of fruit, such as oranges, and lemons.

- Use straight pins to add colorful ribbon streamers to the bottom of your Apple Pomander Ball.

- Use the cloves to make a design or picture on the apple rather than completely covering it.

# Marshmallow Menorah

## MATERIALS

- Ten large marshmallows
- White frosting
- Nine birthday candles
- Rectangular trip of tagboard
- Food coloring
- Milk (optional)
- Styrofoam or paper bowls
- Clean paintbrush

## MORE IDEAS

## LET'S DO IT!!

1. Frost the bottoms of nine marshmallows. Use the frosting to attach the marshmallows to the tagboard, making sure they are in a straight line and evenly spaced.

2. Frost the bottom of the tenth marshmallow. Use the frosting to attach it to the top of the middle marshmallow.

3. Gently poke birthday candles into the tops of the marshmallows.

4. Use watered-down food coloring or food coloring mixed with milk to paint a design or picture on the marshmallows.

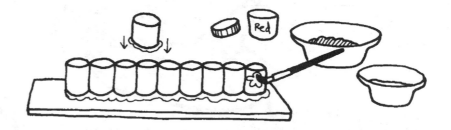

- Have an adult help you light the middle candle, or shammes, and an additional candle each night, in keeping with the Hanukkah tradition.

- Use frosting and small candies to add decorations to your Marshmallow Menorah.

- Learn more about Hanukkah by reading Leslie Kimmelman's **Hanukkah Lights, Hanukkah Nights** (Harper Collins, 1992) or Dennis B. Fradin's **Hanukkah** (Enslow, 1990).

# Clay Dreidel

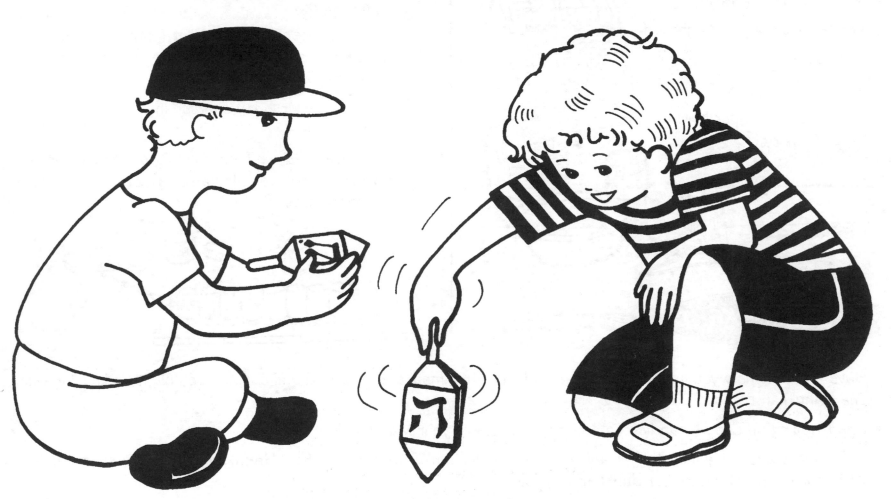

Spin the Dreidel to Play a Hanukkah Game.

# Clay Dreidel

## MATERIALS

- ½ cup (125 Ml) baking soda
- ½ cup (125 Ml) cornstarch
- ⅓ cup (83 Ml) warm water
- Small saucepan
- Spoon
- Pencil
- Half of a craft stick
- Assorted poster paints

## LET'S DO IT!!

1. Cook the baking soda, cornstarch, and water in a small saucepan over a medium heat. Stir until it reaches the boiling point. Remove from the heat.

2. Allow the clay to cool until it can be handled. Knead the clay as it finishes cooling. Shape the clay into a top called a dreidel.

3. As the clay hardens, draw the Hebrew letters on the sides with a pencil. Poke the craft stick half into the dreidel. When the clay has completely dried, paint the Hebrew letters.

ה            ג            כ            ש

Hay         Nun        Gimmel       Shin

Step 3

## MORE IDEAS

- Play the dreidel game! Each player starts with the same number of tokens and puts five into the center. Each player spins the dreidel. The letter that shows on the dreidel when it stops tells what to do: Nun—do nothing; Gimmel—take the center pile; Hay—take half the center pile; Shin—give half of your pile. These four Hebrew letters mean "A great miracle happened there." The last player with tokens is the winner.

- Learn the words to a traditional Hanukkah song entitled *"The Dreidel Song."*

I have a little dreidel, I made it out of clay.
And when it's dry and ready, Oh dreidel I shall play.
Dreidel, dreidel, dreidel, I made it out of clay.
When it's dry and ready, Oh dreidel I shall play.

# Kwanzaa Mat

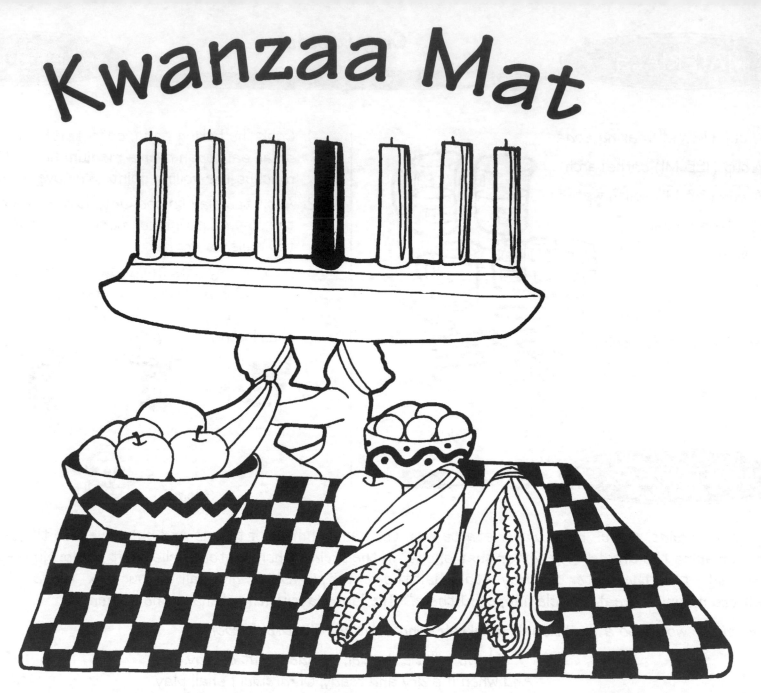

Kwanzaa Is Celebrated Between December 26 and January 1 Each Year.

# Kwanzaa Mat

- 8½" x 11" (22 cm x 28 cm) piece of black construction paper
- Green construction paper strips
- Red construction paper strips
- Scissors

1. Fold the piece of black construction paper in half.

2. Cut slits that are about 1" (2.5 cm) apart from the fold to the top of the paper, leaving a 10" (2.5 cm) space without slits.

3. Weave the green and red strips between the slits in the black construction paper, alternating the colors.

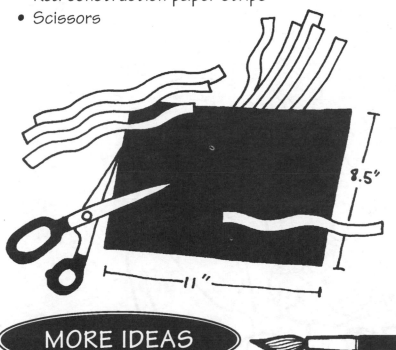

8.5"

11"

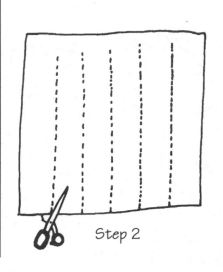

Step 2

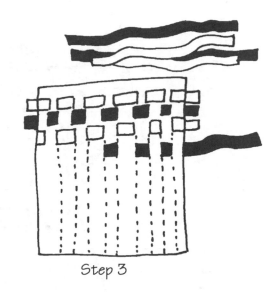

Step 3

**MORE IDEAS**

- Make one large Kwanzaa Mat for the center of the table or a small one for each member of the family.
- Laminate your mat to keep it clean and use it year after year.
- Traditionally, the Kwanzaa Mat is woven from straw. Buy raffia or straw from a craft store to make a mat.
- Make woven mats for any special occasion during which you enjoy a meal. Thanksgiving mats can be brown and orange. Easter mats could be purple, pink, and yellow.
- Read **Seven Candles for Kwanzaa** by Andrea Davis Pinkney (Dial, 1993) to see how one family celebrates Kwanzaa.

# New Year's Noisemaker

Happy New Year!

# New Year's Noisemaker

- Toilet paper tube
- Hole punch
- Markers
- Small square of wax paper
- Rubber band

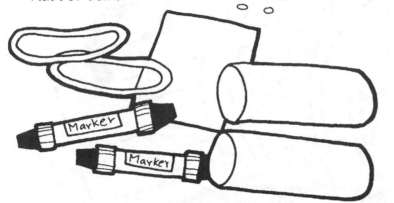

**MORE IDEAS**

1. Punch two holes in the toilet paper tube.

2. Decorate the tube with markers.

3. Wrap a piece of wax paper over one end of the tube. Fasten the wax paper to the tube with a rubber band.

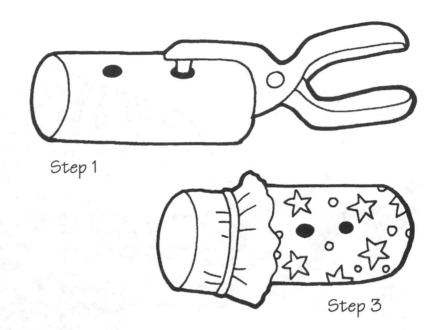

Step 1

Step 3

- Make your New Year's Noisemaker part of a homemade band. Make an oatmeal box drum and a tambourine from two paper plates stapled together with beans or small bells inside.

- To make your New Year's Noisemaker look like an official musical instrument, you can spray paint it silver, adding the wax paper after it is dry.

- Make a jumbo size noisemaker by using a paper towel tube or a wrapping paper tube. You will need to poke the holes with scissors rather than a hole punch. Compare the sounds made with this noisemaker and the smaller version.

# Celebration Cracker

Reveal a Secret Message.

# Celebration Cracker

- 3" x 5" (8 cm x 13 cm) index card
- Pencil or pen
- 12" (30 cm) length of yarn
- Paper towel tube
- Piece of wrapping paper

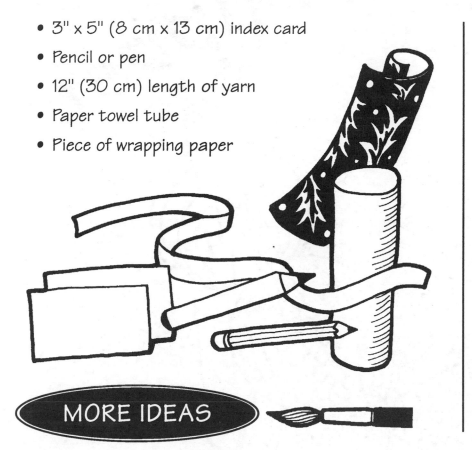

## MORE IDEAS

1. Write a saying, greeting, or message on the index card. Gently poke a hole in the card. Tie the piece of yarn to the hole.

2. Cover the tube with decorative wrapping paper, folding one end into the tube and leaving the other end open.

3. Roll the card and insert it into the tube, leaving the yarn exposed.

4. Give your Celebration Cracker to a friend or family member. Ask that person to pull the yarn "wick" to reveal the message that is hidden inside!

- Pour some confetti in the tube. As the secret message is pulled out, the confetti will be dispersed.

- Firecrackers are used for numerous holidays, such as Independence Day and the Chinese New Year. You can prepare these Celebration Crackers for any of these holidays just by changing the type of wrapping paper and the message written on the index card.

- Celebration Crackers can be personalized for party favors by printing each guest's name on the wrapping paper using fabric paints.

# Chinese Dragon Puppet

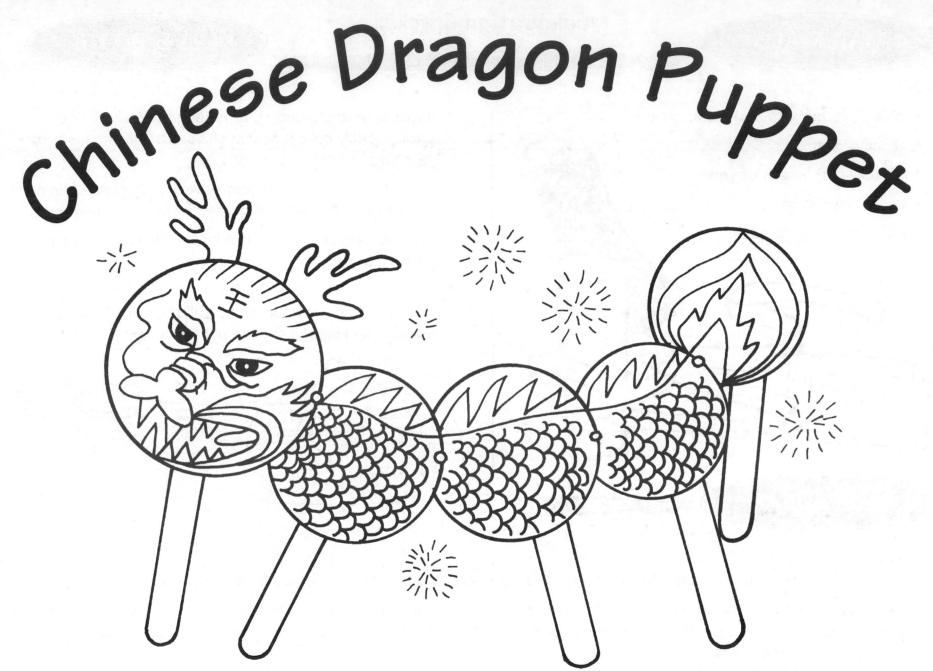

The Chinese New Year Is Celebrated Between January 21 and February 20.

# Chinese Dragon Puppet

- White paper plates
- Craft sticks
- Markers
- Glue
- Hole punch
- Brads

1. Cut circles from the centers of the white paper plates. Cut as many circles as you wish for the desired length of your puppet.

2. Use the markers to design a dragon face on the first circle. Then draw scales, wings, fire designs, or other patterns on the remaining circles.

3. Glue a craft stick to each circle. Allow the glue to dry.

4. Punch one hole on each side of every circle. Stick brads through the punched holes to attach one circle to the next.

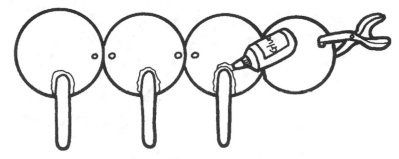

Step 3 and 4

## MORE IDEAS

- Use glitter, sequins, and crepe paper to make the dragon puppet look more dramatic.

- For a parade or group celebration, make a jumbo-sized dragon. Instead of craft sticks, use wooden dowels and make the circles out of heavy paper. Each child can hold a stick and walk in "train" fashion.

- Metal rings can be used instead of brads. Use small rings for the dragon puppet described in the directions shown above and medium rings for the jumbo dragon.

# Pop-Up Hearts Cards

I ♥ You!

# Pop-Up Hearts Cards

## MATERIALS

- 8 ½" x 11" (22 cm x 28 cm) piece of construction paper for the card
- 8 ½" x 5 ½" (22 cm x 14 cm) piece of construction paper for the pop-up hearts
- Scissors
- Glue
- Pencil or pen (optional)

## LET'S DO IT!!

1. To make the pop-up hearts, fan-fold the paper five times, and cut a half heart with both sides of the fold connected.

2. To make the card, fold the paper in half. Use the markers or crayons to decorate the outside of the card.

3. Glue down the outside hearts to the inside of the card. Let the glue dry before closing the card. After the glue has dried, you may wish to write a message to your Valentine inside the card.

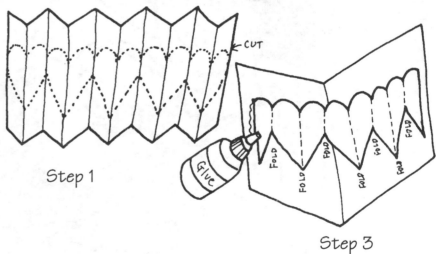

Step 1

Step 3

## MORE IDEAS

- Add decorations, such as glitter, beads, doilies, and lace to the outside of the card.

- Make a string of hearts in all sizes and hang them around your room. Put a friend's name on each heart.

- Fan-folded paper can make festive garlands for any holiday. Examples include shamrocks for St. Patrick's Day, Pilgrim hats for Thanksgiving, and eggs for Easter. Try to decorate each one differently.

# Woven Valentine Pouch

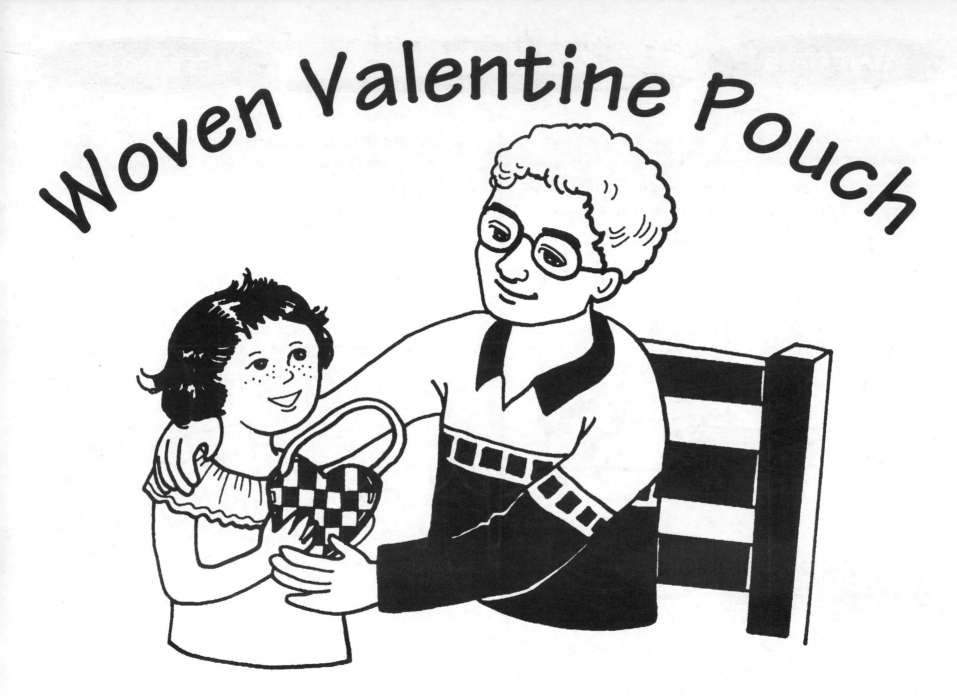

## Weave Your Way into Someone's Heart.

# Woven Valentine Pouch

- Two rectangular strips of construction paper, red and pink
- Scissors
- Ribbon
- Stapler

1. Fold the strips in half.
2. Cut two slits in the folded ends, spaced evenly.
3. Weave the strips into each other so the folded end of one encloses the open side of the other.
4. Round the ends to make the shape look like a heart.
5. Staple a ribbon handle onto the top of the heart shape.

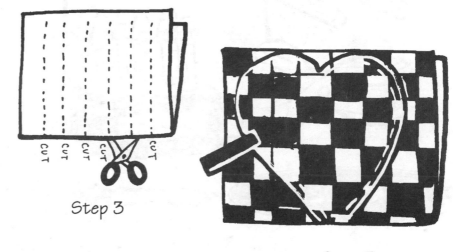

Step 3

Step 5

## MORE IDEAS

- Fill the Woven Valentine Pouch with candy or a special Valentine's message.
- Try cutting more slits in the strips of paper to make a more complicated weave.
- This project can also be done with fabric, but you might want to line it with construction paper to make it sturdier.

# Pencil Toppers

- Construction paper
- Scissors
- Pencils
- Hole punch
- Markers

## MORE IDEAS

1. Draw and cut out a heart design on construction paper, including rectangular tabs on the upper left and lower right of the heart.

2. Punch the holes in the tabs.

3. Decorate the hearts with markers.

4. Slide the pencil through the holes in the tabs, placing the hearts at the top.

Step 1

Step 4

- To give Valentine Pencil Toppers as Valentine's presents, personalize each topper with the name of your valentine.

- Decorate your pencil topper with lace and glitter.

- Decorate the pencil, too! Use fabric paints to make tiny hearts or pink and red stripes.

- Another type of pencil topper involves using a single pipe cleaner. Wrap the middle of the pipe cleaner around the middle of the pencil. Bring the sides up to form the curves of a heart and wrap them just under the eraser. Cut off the excess pipe cleaner.

# Valentine Box

- Empty tissue box
- Wrapping paper
- Construction paper hearts
- Glue
- Tape

1. Use wrapping paper to cover the box on the bottom, sides, and most of the top.

2. Cover the remaining portion of top with hearts, leaving the hole open.

3. Place Valentine's cards in the box.

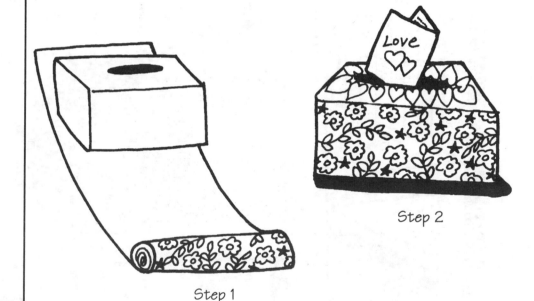

Step 2

Step 1

## MORE IDEAS

- Use plain butcher paper instead of wrapping paper to cover the box. Write quotes or a poem about love on the box.
- You can make the construction paper hearts with your thumb! After folding a piece of paper in half, lay your thumb at an angle so that the middle of your thumb is against the fold. Trace and cut. Use these hearts to cover the top of the box around the hole.
- Make a box to give to a friend or relative. Place a special Valentine message inside of the box.

# Valentine Wreath

## A Circle of Hearts

# Valentine Wreath

- Paper plate
- Tagboard
- Scissors
- Assorted wrapping paper scraps
- Pencil
- Glue stick
- Rubber cement

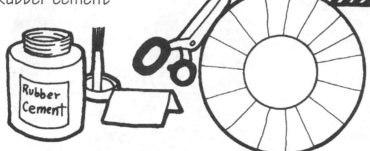

1. Cut the center out of the paper plate. Cut out heart shapes from the tagboard. Trace the tagboard heart shapes onto the wrapping paper and cut out.

2. Glue the wrapping paper scraps to the tagboard with a glue stick.

3. Glue the hearts to a paper plate with rubber cement.

Step 1          Step 3

## MORE IDEAS

- Instead of tagboard, make cushion-type heart shapes out of doubled wrapping paper or wallpaper scraps that are stuffed with tissue paper and then stapled around the edges.

- Use wallpaper samples in Valentine colors to cover the hearts.

- To make a Valentine wreath for your room, choose colors for the hearts that match your decor and keep it up all year long!

# Spring Poem

by Lori Radcliffe

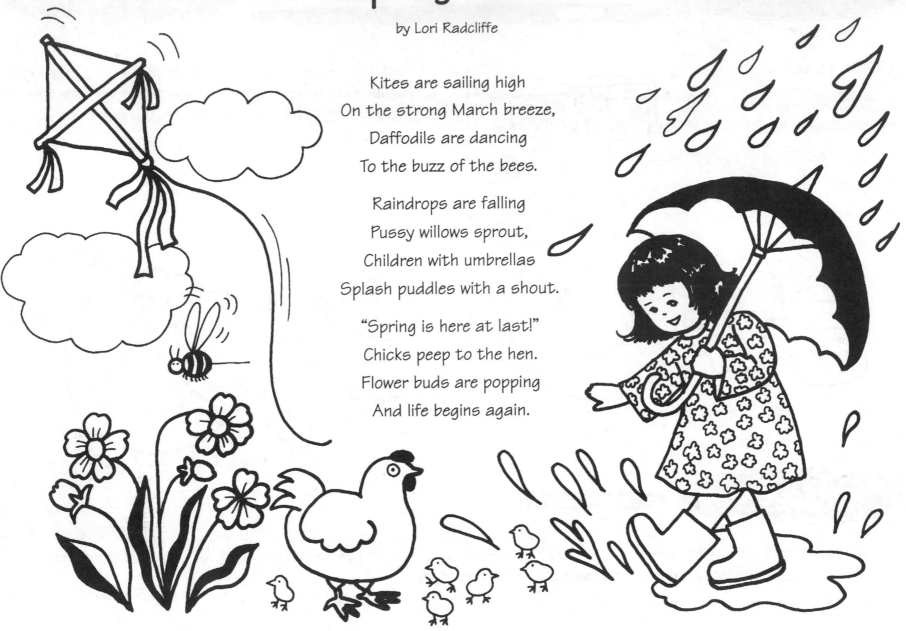

Kites are sailing high
On the strong March breeze,
Daffodils are dancing
To the buzz of the bees.

Raindrops are falling
Pussy willows sprout,
Children with umbrellas
Splash puddles with a shout.

"Spring is here at last!"
Chicks peep to the hen.
Flower buds are popping
And life begins again.

96

# Rainbow Windsock

- Paper plate
- Scissors
- Crepe paper, variety of colors
- Stapler
- String
- Hole punch

1. Cut out the center of the paper plate.

2. To give a rainbow effect, cut and layer pieces of crepe paper, one of each color, of varying lengths. Use these strips as your model for cutting additional pieces of each color. For example, all of the strips of red crepe paper will be the same length, but they will be shorter than the green pieces and longer than the blue pieces.

3. Staple the various lengths of crepe paper around the outside edge of the paper plate, doing all of one color at a time.

4. Poke three holes in the plate and tie three equal lengths of string to the holes. Tie the loose ends of the strings together and add a long piece of string from which you can hang your windsock.

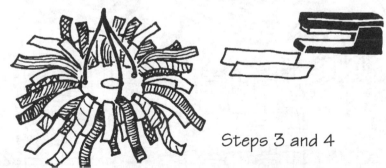

Steps 3 and 4

**MORE IDEAS**

- This Rainbow Windsock also makes a great running kite. Be sure to use string that will not break easily.

- Try making a rainbow using this style of art. A rainbow contains colors in this order: red, orange, yellow, green, blue, indigo (dark blue), violet.

# Sand-Dried Flowers

## Preserving Nature's Beauty

# Sand-Dried Flowers

- Cardboard box
- Sand
- Scissors
- Flowers
- Drinking straws
- Pipe cleaners

1. Cut most of the stem from each flower, leaving about one inch (2.5 cm).

2. Push the stems into a cardboard box that is half full of sand. Sprinkle more sand over the flowers until they are covered.

3. Put the box in a closet for at least two weeks.

4. After removing the flowers from the sand, put the stem of each flower into a drinking straw. Wrap a pipe cleaner around each stem and straw to hold the two together.

## MORE IDEAS

- Use green tissue or construction paper to make leaves. Glue the paper leaves onto the straw stem.

- For a pretty summer bouquet, tie a collection of Sand-Dried Flowers with a raffia bow and place it in a flat basket.

- Experiment to see which types of flowers work best: flat or full, large or small, a small number of petals or a large number of petals, brightly-colored petals or neutrally colored petals.

# Lacy Butterflies

**Wings of Lace**

# Lacy Butterflies

## MATERIALS

- Lace remnants
- Scissors
- White thread
- Pipe cleaners

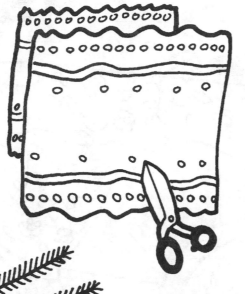

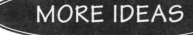

## MORE IDEAS

## LET'S DO IT!!

1. Make two butterflies by cutting two rectangles that are different sizes from the lace remnants. Round the corners of the rectangles.

2. To form each butterfly's wings, pinch and use thread to tie the center of each lace rectangle.

3. Bend a pipe cleaner over each piece of thread and shape it to look like antennae for each butterfly.

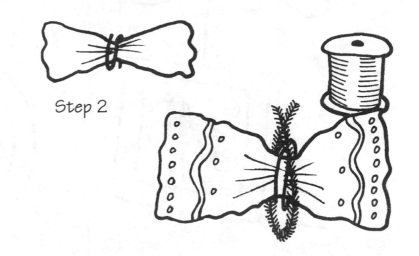

Step 2

- For variety, add sequins and glitter to the wings of your butterfly.

- Use colored lace to make butterflies.

- Make small Lacy Butterflies to use as gift box ornaments or to put on gift tags.

- Before beginning, dye the lace remnants to match the colors of butterflies you have seen in your yard.

- Do research or visit a plant nursery to find out what kinds of flowers attract butterflies. Try planting some of these flowers to attract more butterflies to your home.

# Pressed Flower Suncatchers

**A Touch of Springtime in Your Window**

# Pressed Flower Suncatchers

## MATERIALS

- Flowers
- Heavy book
- Wax paper
- Iron
- Terry cloth towel
- Construction paper frame, any color
- Glue

## LET'S DO IT!!

1. Pick some flowers from your yard or buy some at a store. Press the flowers between the pages of a heavy book. Carefully remove the flowers when they are completely dry.

2. Lay the pressed flowers on a square of wax paper and cover with a similar sized square. Place a towel on top of the waxed paper. Set the iron on a low temperature. Gently iron the towel.

3. Make and glue a construction paper frame to both sides of the suncatcher. Then hang it by a window.

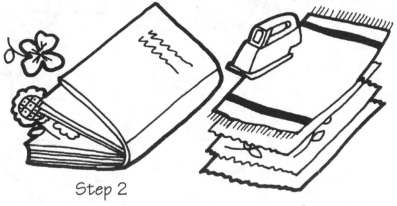

Step 2

Step 4

## MORE IDEAS

- For a different look, use clear contact paper instead of an iron and wax paper.

- Pressed flowers can also be used to make potpourri. Crumble the dried flowers into a jar with a fabric cover or pour them into a fabric bag.

- Color designs on the construction paper frame, adding to the beauty of your suncatcher.

- Make a suncatcher that shows a picture. Arrange the flower petals and leaves to make a picture, like an animal or person

# Japanese Carp Kite

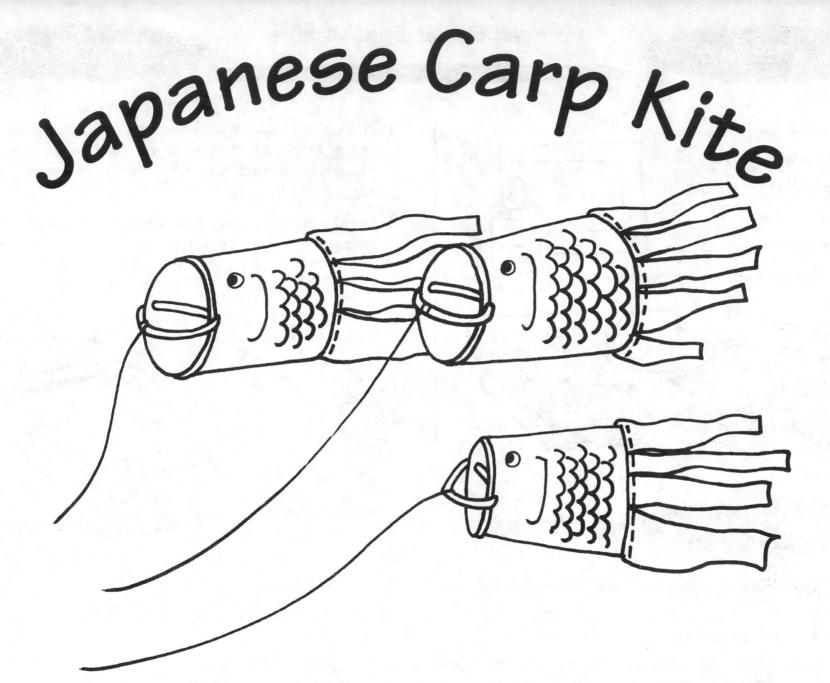

**Carp-Shaped Kites Are Flown in Japan on May 5 for Children's Day.**

# Japanese Carp Kite

- Large paper cup
- Markers
- Scissors
- Crepe paper
- Stapler
- String

1. Cut off the bottom of a large paper cup.

2. Use the smaller end of the cup as the fish's mouth. Then, use the markers to draw the fish's eyes, gills, and fins on the cup.

3. Staple crepe paper streamers to the large end of the cup.

4. Poke two small holes on opposite sides of the fish's mouth. Thread a short string through the two holes and knot the ends. Tie a long piece of string to the center of the short string.

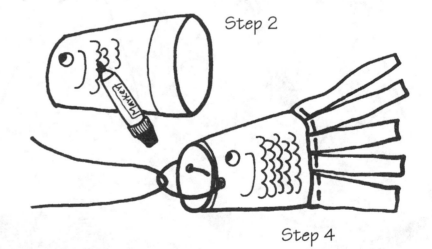

Step 2

Step 4

## MORE IDEAS

- Decorate the Japanese Carp Kite with rows of sequins to look like scales.

- Make a large Japanese Carp Kite with two fish forms cut out of butcher paper. Staple along the top, bottom, and tail. Stuff with tissue paper. Hold the mouth area open with a ring of tagboard.

- You can use your kite as a windsock. Attach the string to a wooden pole and stick it in the ground.

# Egg Carton Caterpillar

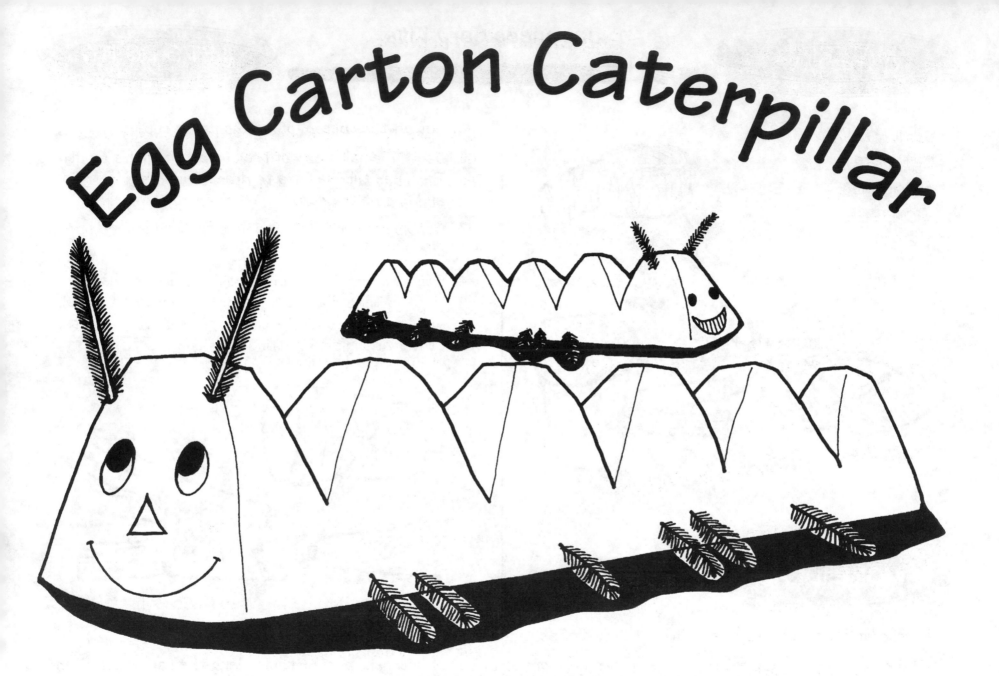

**Captivating Caterpillars Become Beautiful Butterflies**

# Egg Carton Caterpillar

- Cardboard egg carton
- Scissors
- Green paint
- Paintbrush
- Markers
- Pipe cleaners
- Tape (optional)

1. Cut off the top of the egg carton, and cut the bottom half into two strips to make two caterpillars.

2. Place the egg carton strips upside down so the hollow of the cups cannot be seen. Paint them green. Allow the paint to dry. Use markers to add details, such as the eyes, nose, and mouth.

3. Cut two pipe cleaners in half to make antennae. Use the point of your scissors to create small holes at the top of the head before inserting the antennae.

4. Cut four pipe cleaners into thirds. Insert one piece of pipe cleaner on the side of each cup to create the caterpillar's legs.

5. Inside each egg cup, bend down the ends of the pipe cleaners. Tape can be used to secure the antennae and legs.

## MORE IDEAS

Step 1

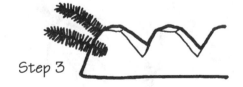

Step 3

- Add more personality to your caterpillars by using plastic wiggly eyes or for clothing and construction paper shoes.
- Other insects can be made from single sections of an egg carton. Try making ladybugs, painted black with red spots, or spiders, painted black with eight pipe cleaner legs.
- Obtain a copy of **The Very Hungry Caterpillar** by Eric Carle (Putnam, 1969) from your library, and pretend to be the caterpillar eating all of the food from the book.

# Stained Glass Butterfly

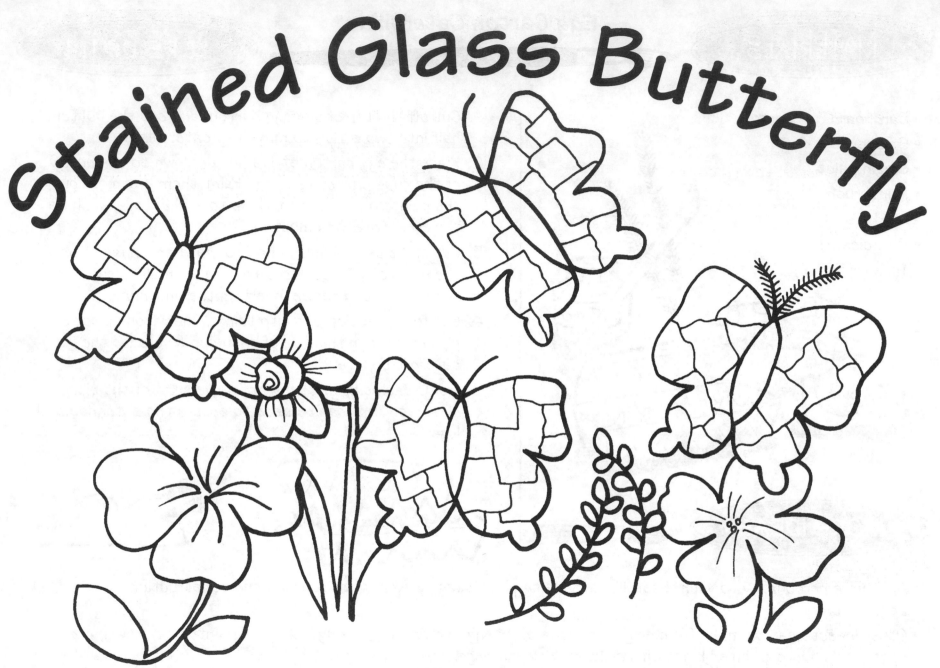

A Touch of Glass

# Stained Glass Butterfly

## MATERIALS

- Wax paper
- Scissors
- Tissue paper, assorted colors
- Glue
- Paintbrush
- String

## LET'S DO IT!!

1. Cut a butterfly pattern out of wax paper.

2. Cut small squares of tissue paper.

3. Paint a small area of the pattern with glue. Apply the tissue paper squares until the glue is covered.

4. Continue gluing on squares of tissue paper until the pattern is covered. Allow the glue to dry. Then glue a second layer of tissue paper squares onto the pattern.

5. After the glue has dried, carefully lift the tissue-paper butterfly from the wax paper. Trim the edges of the butterfly's wings to make them more rounded.

6. Attach string to hang the Stained Glass Butterfly from the ceiling or a curtain rod.

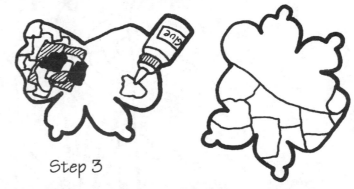

Step 3

Step 5

## MORE IDEAS

- Add twigs or pipe cleaners for antennae.

- Read **Butterflies** by Beth Wagner Brust (Creative Education, Inc., 1991) or **Butterfly and Caterpillar** by Barrie Watts (Silver Burdett, 1985).

- Make smaller stained glass patterns for Christmas ornaments.

# Spring Mobile

## Spring Symbols Hang Together

# Spring Mobile

## MATERIALS

- 8 1/2" x 11" (22 cm x 28 cm) construction paper, white and assorted colors
- Scissors
- Pencil
- String
- Stick or wire coat hanger

## LET'S DO IT!!

1. Cut out the following spring shapes from pieces of different colored construction paper: large cloud, raindrops, flower, bird.

2. Punch a small hole in the top of the cloud. Use string to connect the cloud to the middle of a stick or wire coat hanger.

3. Punch a small hole in the bottom of the cloud for each spring shape you have cut out of the construction paper.

4. Use string to connect each spring shape to the cloud.

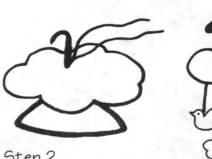

Step 2

Step 4

## MORE IDEAS

- Write a favorite spring poem on the cloud, or better yet, compose one of your own!

- Decorate the flower and bird, using a variety of materials, such as markers, colored cotton balls, seeds, and glitter.

- If tying the strings to the cloud is too difficult for small hands, tape them on.

- Cut two identical cloud shapes. Glue or staple the edges of the clouds, leaving only a small opening. Then, stuff the clouds with tissue paper. Close the opening with glue or staples.

- Take a spring nature walk. Notice all of the new growth on plants and any animal babies.

# Leprechaun Marionette

**St. Patrick's Day Is Celebrated on March 17.**

# Leprechaun Marionette

- Tagboard
- Pencil
- Markers
- Scissors
- Hole punch
- Paper cup
- Green paint
- Paintbrush
- 4 Green construction paper strips 1" (2.5 cm) wide
- Glue
- Paper towel tube
- String

1. Draw and color the face and leprechaun's hat on the tagboard. Cut them out, and punch a hole in the hat.
2. Paint a paper cup green for the leprechaun's body.
3. Fold the strips accordion-style for the leprechaun's arms and legs. Draw hands and feet on the ends of the strips. On the opposite ends, punch a hole in each strip. Glue the face to the closed end of the cup. Glue one arm and one leg to each side of the cup.
4. Tie one end of a short string onto the middle of a paper towel tube. Tie the other end of the string to the hole in the hat. Tie two longer strings to the outside edges of the tube and connect them to the hands using glue. Tie two longer strings to the tube, placing each between the hat and an arm string and connect them to the middle of the legs, using glue.

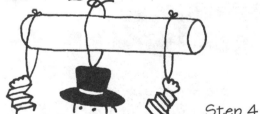

Step 4

## MORE IDEAS

- Make a puppet theater for your marionette out of a large cardboard box. Cut a large hole in front, spray paint the box, and staple a thin fabric curtain to the inside around the top of the hole. When it is show time, hold the curtain open with clothespins.

- Every leprechaun needs to have a pot o' gold. Paint a paper cup black and fill it with gold-covered chocolate coins.

# Shamrock Potato Prints

- Potato
- Knife
- Pencil
- Green paint
- Styrofoam or thick paper plate
- White construction paper

## MORE IDEAS

1. Cut a potato in half. Draw an outline of a shamrock on the cut surface of one half.

2. Carve away some of the potato around the shamrock shape. Be sure the shamrock shape clearly sticks out from the rest of the potato.

3. Pour some green paint onto the plate. Dip the potato into the paint and stamp onto the white construction paper to make shamrock designs.

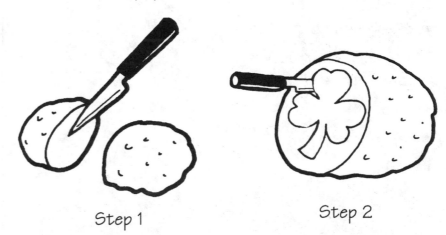

Step 1          Step 2

- Potatoes are especially appropriate for St. Patrick's Day since Ireland is famous for its potato crops. However, any design can be carved into a potato. To make carving easier, press a cookie cutter shape into the potato. Then, chisel away the parts of the potato that are around the outline of the shape that is made by the cookie cutter.

- Experiment with stamping the potato prints onto different types of paper, such as thin, thick, and porous. You might also wish to experiment with stamping different types of materials, such as fabric, wood, and plastic.

- Use markers to draw a picture using your shamrock stamps. For example, you could make a shamrock person by adding lines for legs, arms, hair, facial features, and clothes.

# Pot-O'Gold

LET'S DO IT!!

- Sheet of aluminum foil, approximately 12" (30 cm)
- Pencil with a sharp point
- Black pipe cleaner
- Chocolate-filled gold coins

1. Fold the sheet of foil in half, and fashion a bowl shape by molding it around your fist. Continue pressing the foil until you get the shape of a pot.

2. Use a sharp pencil point to poke small holes in opposite sides of the foil pot.

3. Bend the pipe cleaner to make a handle for the pot and connect the ends to the holes.

4. Fill the pot with chocolate-filled gold coins.

Step 3

Step 1

## MORE IDEAS

- More permanent pots can be made from clay or papier mâché and painted black like the leprechauns' pots that are described in stories.

- Make smaller Pots-O' Gold as St. Patrick's Day party favors. You might wish to use real coins, such as pennies, to fill the pots.

- Hide chocolate-filled gold coins around the house. Invite family members or friends to look for the coins and place them in the foil pot when they are found. You may also wish to make several foil pots so that the coins can be placed in each individual's pot as they are found.

# Naturally Dyed Eggs

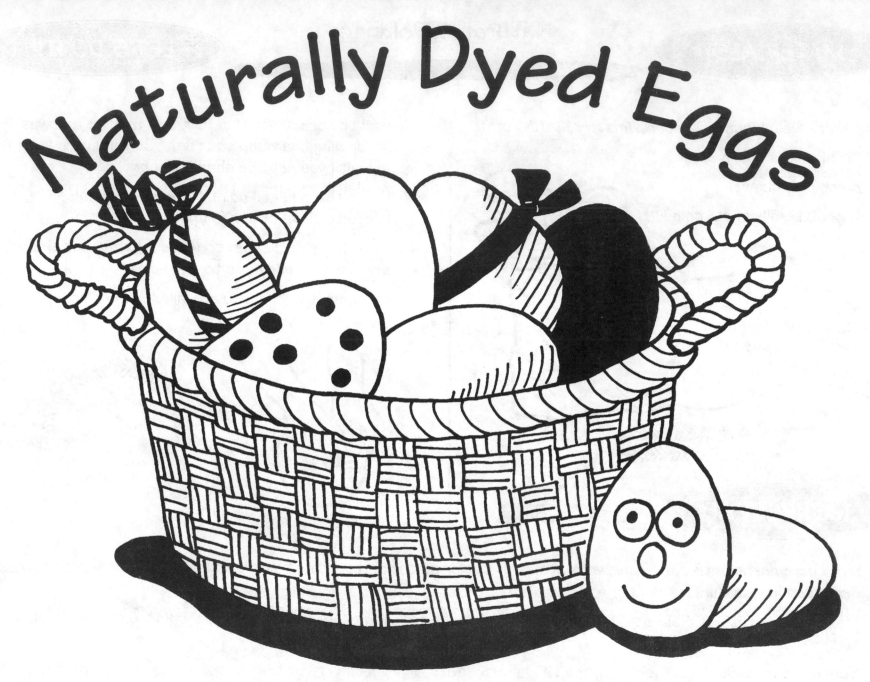

## Humpty Dumpty Never Looked This Good!

116

# Naturally Dyed Eggs

- Hard-boiled eggs
- Saucepans and water
- Frozen spinach block (for green dye)
- Blackberries (for purple dye)
- Onion skins (for tan dye)
- Coffee bags (for yellow dye)
- Beets (for pink dye)
- Carrots (for peach dye)
- Plastic or Styrofoam containers, one for each color dye
- Large spoon
- Egg cartons

1. Separately boil the spinach, blackberries, onion skins, coffee bags, beets, and carrots until each sauce pan of water is brightly colored. If only one saucepan is available, be sure to thoroughly clean it after each dye is made.
2. Carefully drain the colored water from the food items into plastic or Styrofoam containers.
3. Gently place each hard-boiled egg into a container of dye. Remove the eggs from the dyes, using a large spoon.
4. Let the eggs dry on upside-down egg cartons.

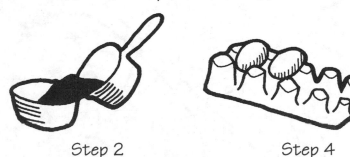

Step 2              Step 4

- The longer you leave the eggs in the dyes, the brighter the colors will be. Using natural dyes will take longer than using commercial ones. If you find the colors are not as bold as you would like, try adding some vinegar.
- Egg decorating is limited only by your imagination. Before dying the eggs, try drawing faces or pictures on them with crayons. After dying the eggs, add lace and ribbon remnants, sequins, stickers, glitter, and yarn; or use movable plastic eyes and permanent markers to make a family portrait of colored egg faces.
- Clean a plastic berry basket. Weave lace through the holes in the basket. Place the dyed eggs in the basket for Easter.
- Make an egg tree by using a large branch "planted" in a sand-filled bucket and decorating it with your collection of Naturally Dyed Eggs.

# Bunny Windsock

## A Blowing Bunny

# Bunny Windsock

- White construction paper, two pieces 8 ½" x 11" (22 cm x 28 cm)

- Pink construction paper

- Markers

- Stapler

- Scissors

- Glue

- Six pipe cleaners

- Hole punch

- Yarn or ribbon

1. Draw a bunny face on the center of one piece of white construction paper. Roll the paper into a cylinder and staple.

2. Cut two outer ears from white construction paper and two inner ears from pink construction paper. Glue the pink inner ears onto the white outer ears. Then, staple the ears to the cylinder.

3. Add whiskers to the bunny face by gluing three pipe cleaners to each side of the nose.

4. Punch three holes in one end of the cylinder and tie a short piece of yarn to each. Tie the loose ends of the yarn together and attach a long piece of yarn. Then, hang the windsock by the long piece of yarn.

## MORE IDEAS

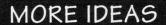

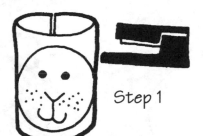

Step 1

Step 2

- For the bunny's ears you can use fabric, doubled and lined, with thin wire to make ears stand up straight. Use a pink patterned material for the inside of the ears.

- Add four or five cotton balls back of the windsock as the bunny's tail.

- Instead of drawing a bunny, make a self-portrait windsock, using yarn for hair. Make the ears and nose from construction paper and glue them on separately.

- Use white and pink bunny ears to make yourself a bunny hat. Measure a tagboard band to fit around your head, and staple it in place. Then, staple the ears to a tagboard band.

# Confetti Eggs

**Time to Crack a Few Eggs.**

# Confetti Eggs

- Eggs
- Straight pin
- Food coloring
- Vinegar
- Bowls
- Large spoon
- Egg cartons
- Confetti
- Tape

1. Poke a small hole in one end of the egg and larger hole out of the other end. Very carefully blow the contents of the egg out of the shell and into a bowl.

2. Gently place the shells in bowls of vinegar mixed with food coloring. Soak the shells until they are dyed. Use a large spoon to remove the eggs from the bowls. Place the eggs on upside-down egg cartons and allow them to dry completely.

3. Slightly enlarge the hole at the end of each egg. Fill the eggs about ½ full of confetti. Use tape to close the hole in each egg.

Step 1

Step 3

## MORE IDEAS

- Egg tosses with Confetti Eggs are a smash! Arrange two lines facing each other and have participants toss the eggs back and forth, moving farther away from each other after each turn.

- Use Confetti Eggs at any spring party. After the eggs are filled, let guests squeeze them and sprinkle confetti over the heads of their friends.

- For a more finished look, the holes can be covered with tissue paper that is dipped in egg white to make it stick to the shell.

# Paper Bag Piñata

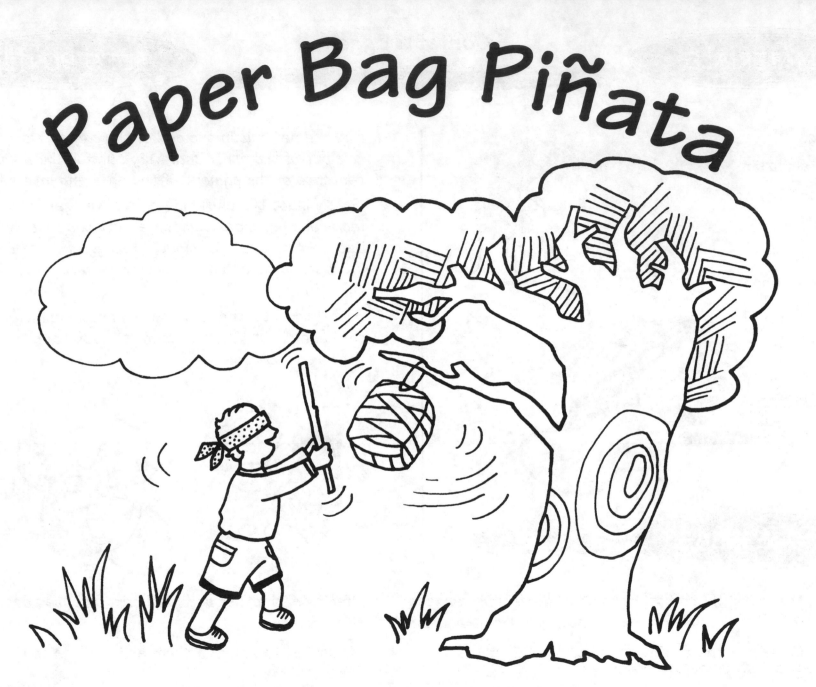

A Holiday or Birthday Bash

122

# Paper Bag Piñata

- Paper grocery bag
- Colored tissue paper
- Scissors
- Glue
- Newspaper
- Candy and small toys
- Stapler
- Rope

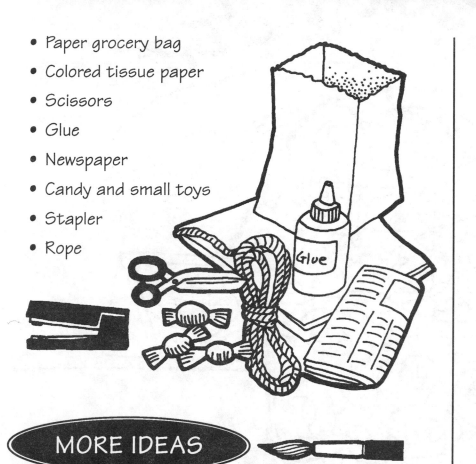

## MORE IDEAS

1. Cut the tissue paper into strips that are about 4" (10 cm) wide. Snip the edges to make fringe.

2. Glue the tissue paper in a circular pattern around the paper grocery bag.

3. Stuff the bag with wadded up newspaper, candy, and toys. Close the opening of the bag and staple.

4. Use rope to suspend the piñata from the limb of a tree.

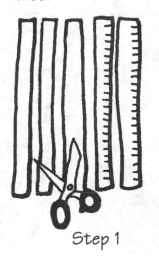

Step 1

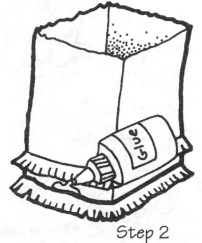

Step 2

- Use a stick wrapped with strips of fringed tissue paper to break the piñata. This piñata is easy to make but not easily broken.

- For an even easier version, design a picture on the piñata and decorate it with colored markers. Glue on construction paper arms and legs or glue on yarn hair for an added affect.

- Make your own nachos for a Mexican celebration: top tortilla chips with cheese and jalapeño peppers and put in the microwave or a warm oven until the cheese is melted. Serve with salsa (hot sauce) and/or sour cream.

# Mother's Joy Jar

Mom, You Make Me Feel Good When . . .

# Mother's Joy Jar

- Canning jar with dome lid and band
- 7" (18 cm) square of fabric
- Construction paper
- Pen
- Scissors

1. Cut the construction paper into strips. On the strips, write things that would give your mom joy, such as "You make me feel good when you kiss my nose"; "I like it when you read to me"; "Thank you for making spaghetti so often!"

2. Roll up the strips and place them in the jar. If the jar is not very full, write some more things on additional strips of paper.

3. Separate the lid from the band. Place fabric over the lid. Snap the fabric covered lid into the band. Place the lid on the jar and twist to close it.

Step 2

Step 3

## MORE IDEAS

- To make the fabric square look fancier, cut it with pinking shears.
- Use the construction paper strips as "coupons" for extra chores that you can do to help out your mom. Examples include "I owe you an ice cream cone" and "I'll do the dishes today."
- Use fabric paints on the jar to paint a coordinating design with the fabric lid or to write a special message, such as "I Love You, Mom!"

# Tissue Paper Bouquet

**Flowers That Are Always Fresh**

# Tissue Paper Bouquet

- Colored tissue paper, cut into large squares
- Scissors
- Pipe cleaners
- Florist tape

1. Fan-fold the tissue paper.
2. Use the scissors to round the edges on both sides of the folded tissue paper.
3. Wrap a pipe cleaner around the middle of the folded tissue paper. Fluff the paper to give it fullness.
4. Wrap florist tape from the bottom of the flower to the bottom of the pipe cleaner.

## MORE IDEAS

- Each of the flowers can be cut differently on the edges of the folded tissue paper. Craft stores sell inexpensive scissors with different blade patterns.

- Put two different colors of tissue paper together or streak a single color with colored markers for added color.

- Make your own vase out of a decorated juice can. Present your Tissue Paper Bouquet to your mom for Mother's Day.

# Summer
by Lori Radcliffe

Sand in my suit,
Sand in my hair,
Squealing and laughing
Sand everywhere!

Water from hoses,
Water in the pools,
Splashing and diving
And swimming that cools.

Time to relax,
Time to sleep late,
Reading and lounging
With friends who are great.

Hot summer sunshine,
A cold ice cream treat,
Hot dogs and sparklers
And dirty bare feet!

# Yarn Art

- Cardboard square, 4" x 4" (10 cm x 10 cm)
- Thick yarn, two colors
- Scissors
- Glue

MORE IDEAS

1. Draw a simple summer picture on your cardboard square. You might wish to draw a boat, a flower, or a butterfly.

2. Decide which color of yarn will be for the background and which will be for the picture you drew. Cut several pieces, each 12" (30 cm) long, of both colors of yarn.

3. Rub glue over part of your picture. Zigzag a piece of yarn onto the glue. Add more glue and yarn until the picture is complete. If your fingers get too sticky, wash your hands. Then do the same thing for the background.

Step 1          Step 3

- Make more elaborate pictures using additional colors of yarn.

- Use embroidery thread to make a smaller picture using the same technique as you did for the yarn art.

- Glue yarn only on the part of the picture that you drew. Do not cover the background with any yarn. Pour paint onto a Styrofoam or sturdy paper plate. Dip the yarn picture in the paint. Remove it and press the yarn picture onto a piece of white construction paper to make a yarn print.

# Sun X-Ray Pictures

Art From Sunlight

# Sun X-Ray Pictures

## MATERIALS

- Sunlight
- Construction paper
- Objects of various shapes
- Markers (optional)

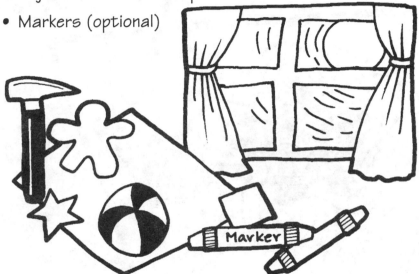

## MORE IDEAS

## LET'S DO IT!!

1. Go outside and place the objects on a piece of construction paper. Leave this in the sun for at least an hour.

2. When the objects are removed, the paper will be faded, except for the areas covered by the objects.

3. You may wish to use the markers to add a design on the faded areas of the picture.

Step 1          Step 3

---

- Place the objects so the pattern will combine to make a picture. For instance, you can make a face using nuts and bolts.

- Make theme-oriented design for example, types of leaves, pieces of silverware, shapes (circle, square, etc.).

- After completing the x-ray portion, draw other features onto the picture. For instance, if you make an x-ray picture of a hammer, make it into a hobby horse by drawing a face on the hammer head and a mane along the handle.

# Melted-Crayon Flowers

## A Lovely Way to Recycle Old Crayons

# Melted-Crayon Flowers

## MATERIALS

- White construction paper
- Black crayon, marker, or chalk
- Crayon shavings in various bright colors
- Heat from the sun

## LET'S DO IT!!

1. Draw an outline of a flower shape on a piece of construction paper.

2. Place the crayon shavings within the lines of the flower shape to make a colorful design.

3. Carefully place the picture outside in the sun. Place a rock, or some other heavy object, on the paper to keep it on the ground. Allow the crayon shavings to melt.

4. If possible, leave the picture outside overnight to allow the melted crayon to harden.

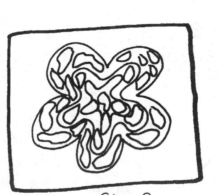

Step 2

Step 3

## MORE IDEAS

- Summertime flowers are bright and beautiful, but you may wish to experiment to see what other types of designs you can create with melted crayon shavings.

- Shave your crayons with a vegetable peeler, cheese grater, or manual pencil sharpener. Be sure to ask an adult for permission before using any of these tools to shave your crayons.

- Make melted-crayon designs on tagboard frames for your creations, as well as any other artwork. Ask your friends to guess how you created these masterpieces.

# Rocking Sailboat

**Have a Rocking Good Time!**

# Rocking Sailboat

- Light weight paper plate
- Pencil
- Scissors
- Markers

1. Fold the paper plate in half. Then unfold it.

2. Draw a boat design with the mast and sail above the fold line and the top of the boat on the fold line.

3. Cut around the mast and sail.

4. Fold the plate again, using the original fold line, to bring the mast and sail up.

5. Use markers to color the waves, boat, and sail.

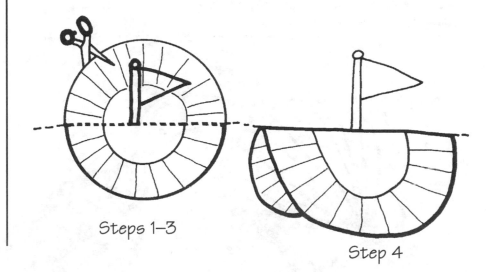

Steps 1–3

Step 4

## MORE IDEAS

- For sparkling waves, add glue and glitter to the colored wavy lines.

- Glue on fish-shaped crackers, so it will look like there are fish in your ocean.

- Personalize your boat by giving it a name and writing it on the side. Pick your favorite number and write it on the sail.

- Make your Rocking Sailboat into a card by writing a note inside.

# Painted Sea Shells

**Capture the Serenity of the Sea.**

# Painted Sea Shells

- Whole sea shells
- Paints
- Fine paintbrushes
- Ribbon
- Hot glue gun

1. Gather or buy whole shells.

2. Paint the grooves and lines of the shells, using contrasting colors.

3. Glue a loop of ribbon to the top of each shell so you can hang it up.

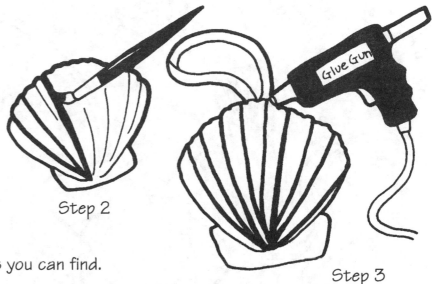

Step 2

Step 3

## MORE IDEAS

- Start a shell collection. See how many different varieties you can find.

- Instead of using paints, squeeze glue into grooves of shells and sprinkle with glitter.

- You can make a game with shell shapes. Trace around a number of different sizes and shapes of some shells. Time a friend with a stopwatch to see how long it takes him or her to match the outlines of the shapes with the actual shells.

- Paint lots of small shells and use them for collages or making ocean jewelry. A bracelet can be made with shells attached to wide elastic with fabric glue. The ends of the elastic are sewn together. Very small shells can be used to make earrings—posts and clips can be purchased from craft stores.

- If it is not easy for you to obtain shells, try painting the lines and grooves of unusual rocks instead.

# Paper Plate Fish

"Gone Fishing!"

# Paper Plate Fish

## MATERIALS

- Two small paper plates
- Scissors
- Stapler
- Markers

## LET'S DO IT!!

1. Put the plates together. Cut a small triangle from both plates.

2. Reverse one plate. Place the two plates back together again, making sure the triangles match up to create the mouth of the fish.

3. Staple around the edges of the plates to keep them together. Staple one triangle onto the plates as the tail. Staple the other triangle onto the plates as a top fin.

4. Draw a fin and an eye on each side of the fish. Then decorate the fish with markers.

Step 1

Step 3

## MORE IDEAS

- Make a school of goldfish by making a collection of paper plate fish and painting them orange.

- Use small pieces of aluminum foil to make shiny scales. Glue them onto the body of the fish. Then have your fish act out the story *The Rainbow Fish* by Marcus Pfister (North-South Books, 1992).

- Make an ocean mural. Paint butcher paper with watered down blue paint. When dry, glue on a layer of sand to the bottom. Make some seaweed using yarn and glue it onto the mural. If you have real shells, glue them on, as well. As a final touch, glue on your Paper Plate Fish.

# Colored Sand Picture

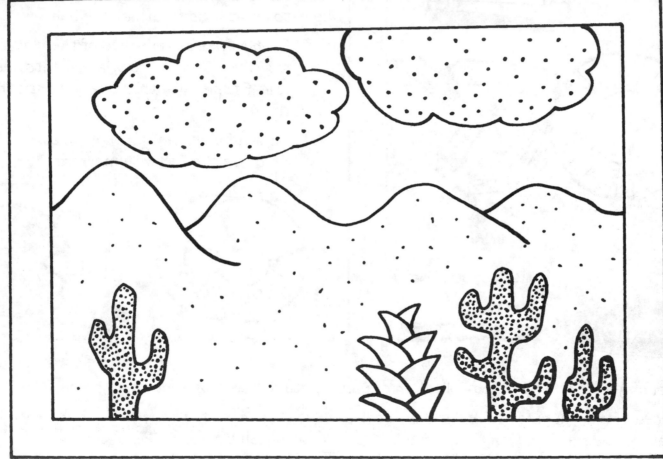

**Sandy Scenes**

# Colored Sand Picture

- Sand
- Resealable plastic bags, one for each color
- Poster Board
- Glue

1. Pour some sand into several resealable plastic bags. Add a few drops of food coloring to each.

2. Seal the bags. Shake until the color mixes evenly in the sand. Open the bags. Let the sand dry for a couple of hours.

3. Plan your picture so you will know where you want each color.

4. Smear glue on the areas where a particular color of sand should go. Sprinkle the sand onto the glue.

5. Allow the glue to dry. Gently shake off any excess sand.

6. Repeat Steps 4 and 5 for each color of sand until your picture is complete.

## MORE IDEAS

Step 4

- Combine sand colors and mix only slightly. Shaking the sand onto the picture will give a rainbow effect.

- Instead of sand, try coloring and designing pictures with salt.

- Make layered sand designs in bottles with your remaining colored sand. Use interestingly shaped bottles and tilt in different directions to create a variety in the designs.

# Sand Candles

**Summer Fun With Sand and Wax**

142

# Sand Candles

- Paraffin wax
- String
- Sand
- Container

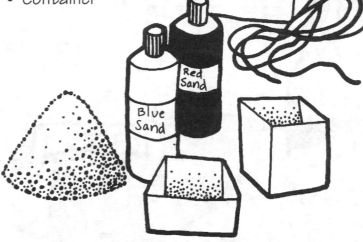

1. Obtain sand from the beach, a sandbox, or a building supply store. Wet the sand, place it in the container, and create a mold of any shape by hollowing out the center. Be sure the bottom of the mold is flat.

2. Melt the paraffin wax according to the directions on the package. Pour the wax into the sand mold.

3. Hold the string in the center of the wax so that it touches the bottom of the mold.

4. Use sand to gently cover the wax showing at the top of the mold. Cut the string so that the tip is sticking out of the sand.

5. The candle is ready to use when it has completely hardened on top.

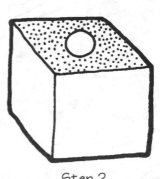

Step 2

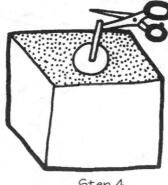

Step 4

## MORE IDEAS

- Put crayon shavings in wax while it is melting to make colored candles.
- Outline the sides of the mold with seashells.
- Melted wax can also be poured into small milk containers to make cube candles. Add layers in different colors as each previous layer dries.

# Travel Desk

## A Desk That Can Go Anywhere

# Travel Desk

## MATERIALS

- Box with lid (A box that holds reams of copier paper is ideal.)
- Sharp matte knife
- Glue
- Paint, your favorite color
- Paintbrush

## LET'S DO IT!!

1. Turn the box over and cut a half circle in the middle of each long side so the desk can be placed over your legs.

2. Turn the lid so the inside surface shows. Glue it to the bottom of the box to create a tray for the top of the desk.

3. Cover the desk with your favorite color of paint.

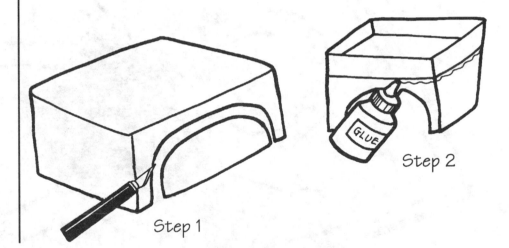

Step 1

Step 2

## MORE IDEAS

- Glue a paper cup to one corner of your desk. Place your supplies, such as markers or pencils, in the cup.

- Add paper pockets to the sides of the desk to hold coloring books, playing cards, books, pens, stamps, etc.

- Draw pictures on the sides of the desk of each place you visit if you take a trip or write your favorite memories about your vacation on the top of your desk.

- If you can't find a lid, trim about 2" (5 cm) from all four sides of the box. Create a tray by gluing the strips so that they stand up on the bottom of the box.

# Painted Beach Towel

**A Towel That Is Distinctly You**

# Painted Beach Towel

- Terry cloth towel
- Fabric paints
- Acrylic paints
- Paintbrush with stiff bristles

1. Lie on a terry cloth towel, have a friend outline your body with fabric paint.

2. With acrylic paint a bathing suit and facial features to match your own!

3. Paint a beach or pool in the background.

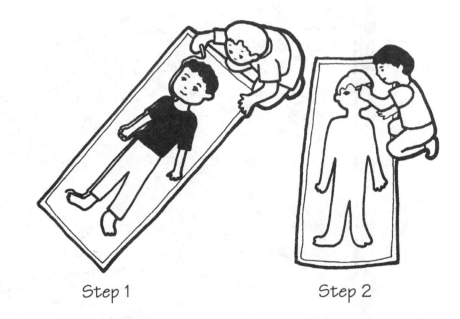

Step 1          Step 2

## MORE IDEAS

- Footprints and handprints also look cute when painted on a beach towel.

- Paint hand towels with Christmas trees or spring flowers to give as gifts.

- For a summer party activity, have all guests sign their names on the host's towel using fabric paints.

# Memory Bookmark

Keeping Memories Fresh

# Memory Bookmark

- Poster board, two colors
- Small outline map of the United States
- Pencil
- Scissors
- Glue
- Assorted postcards

1. Cut a long rectangle and the outline shape of the United States from two colors of poster board.

2. Glue the United States cutout to the top of the rectangle.

3. Cut out pictures from postcards. Glue the pictures onto the rectangle below the United States cutout.

4. Allow the glue to dry. Laminate the bookmark or cover it with contact paper.

**MORE IDEAS**

- Pictures from photographs can be used instead of postcards.

- If you will be traveling within your state, glue a cutout of your state to the top of the bookmark.

- If you take a trip, list the books you would like to read while traveling on the back of the bookmark. After you read them, check them off.

- Place a more detailed map at the top of the bookmark. Use the top part of the bookmark to show where you have traveled. In red pen, draw lines from one destination to the next. Make sure to start off and end with a big red X.

- When your Memory Bookmark is complete, write a few lines on the back about your favorite parts of your vacation.

# Postcard Puzzle

Putting It All Together

# Postcard Puzzle

## MATERIALS

- Postcard
- Heavy paper or tagboard
- Glue stick
- Scissors
- Pen
- Resealable plastic bag

## LET'S DO IT!!

1. Cut and glue a postcard-sized piece of heavy paper or tagboard to the back of a postcard.

2. Draw puzzle lines on the back and cut the pieces apart.

3. Store the puzzle pieces in a resealable plastic bag.

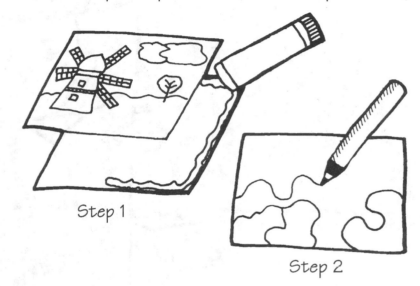

Step 1

Step 2

## MORE IDEAS

- Laminate the Postcard Puzzle or cover it with clear contact paper for durability.

- Glue two postcards together, back to back, before making it into a puzzle. See how long it takes a friend to realize there are two pictures!

- Make this activity more difficult by making numerous Postcard Puzzles and storing them in a single resealable bag.

- Encourage friends and relatives to send you postcards during their vacations so you can start a collection.

- If you do not have any postcards, select pictures from magazines and glue them onto tagboard or poster board to make puzzles.

# Portrait Pencil Holder

Father's Day Is the Third Sunday in June.

# Portrait Pencil Holder

- Juice can, cleaned and dried
- White construction paper
- Construction paper scraps
- Markers
- Scissors
- Glue

1. Cut and glue a piece of white construction paper to fit around the juice can.

2. Use the construction paper scraps to make a tie, shirt collar, arms, and accordion-folded legs.

3. Draw your father's face onto the can, and glue on the paper pieces in appropriate places.

4. Give the Portrait Pencil Holder as a gift on Father's Day.

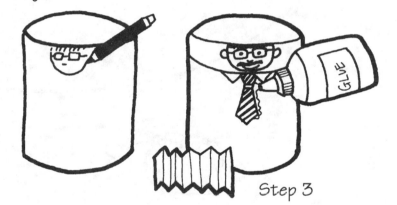

Step 3

## MORE IDEAS

- Glue yarn that is the color of your father's hair around the top of the can.

- If you purchase small novelty erasers in the shapes of different types of balls used in sports, glue the one that represents your father's favorite in the construction paper hand on the pencil holder.

- Draw and cut out a picture of something that represents your father's favorite hobby. Glue that picture to a construction paper hand on the pencil holder.

- A simpler pencil holder can be made by covering the can with wallpaper and decorating it with rickrack, stickers, glitter, construction paper shapes, etc.

# Change Bucket

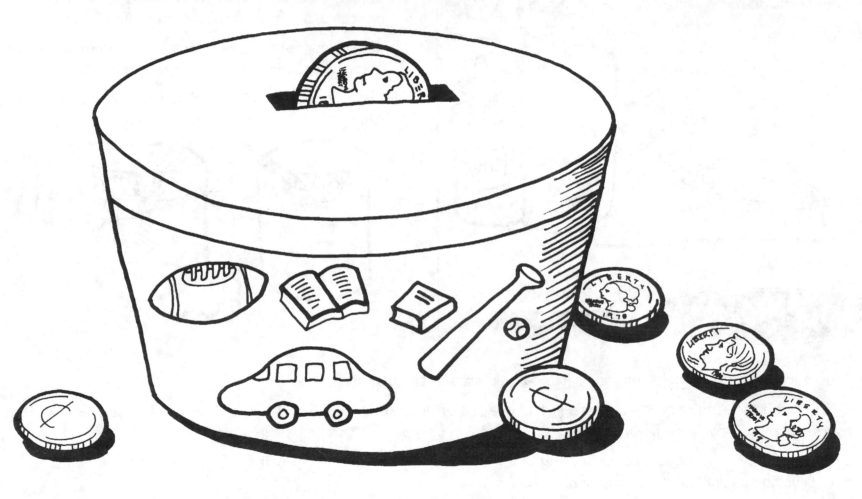

"A Penny for Your Thoughts"

# Change Bucket

- Small margarine tub with lid
- Sharp matte knife
- Butcher paper
- Glue

1. Cut a coined-sized slit into the center of the lid.

2. Wrap the margarine container with a piece of butcher paper. Glue the paper to the bottom of the container.

3. Draw pictures of your father's favorite things on the bucket. Possible pictures include football, television, pizza, book.

4. Give the Change Bucket to your father on Father's Day.

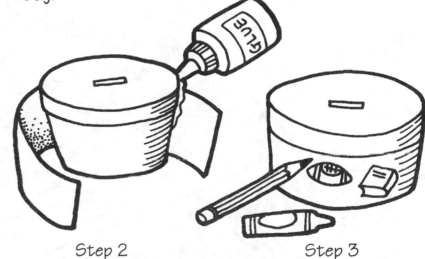

Step 2                                    Step 3

**MORE IDEAS**

- A Change Bucket can become a bank just by using a larger tub.
- Cover the container with wrapping paper. Create an ornament for the top of your Change Bucket that relates to the pictures on the paper. For example, if the paper has ships on it, draw and cut out a boat with a tab at the bottom from a piece of tagboard or poster board. Fold the tab and glue it onto the lid of the margarine container so that the boat stands up straight.

# Fireworks Hat

**"With Liberty and Justice for All"**

# Fireworks Hat

## MATERIALS

## LET'S DO IT!!

- Full sheet of newspaper
- Stapler
- Construction paper scraps (red, white, and blue for an American hat)
- Scissors
- Glue

1. Fold a full sheet of newspaper in half.
2. Pull the two top corners down to meet in middle.
3. Fold the bottom edge up on each side of hat.
4. Snip the ends and fold up again.
5. Cut out firework bursts from scraps of colored construction paper and randomly glue them onto the hat.

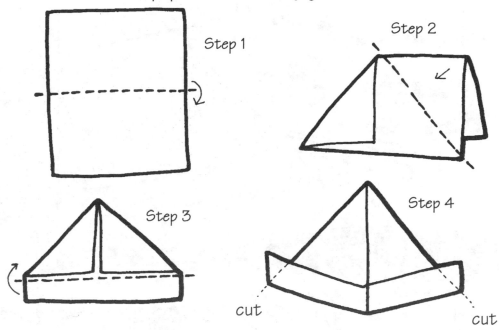

Step 1

Step 2

Step 3

Step 4

cut

cut

## MORE IDEAS

- Snip a tiny hole in the top of the hat and poke a small flag through it. Poke or glue flags all around the hat.
- Add colored streamers to the back or top of the hat.
- Decorate the hat with star stickers.
- Write a patriotic phrase, such as "Happy Independence Day!" on one of the firework bursts.

# Mirror-Image Flag

- 8 ½" x 11" (22 cm x 28 cm) white construction paper, cut in half lengthwise
- Colored paints, selected according to the colors in the flag you choose
- Paintbrushes
- Plastic drinking straw
- Glue
- Stapler

1. Fold the white construction paper in half. Then unfold it.

2. Paint the basic design of a flag on the right side of the paper. You may wish to make the flag look like the one used by your country, state, or province.

3. Refold the paper and press. Unfold the paper, and allow the paint to dry.

4. Reverse the fold so that both the original flag and the mirror-image flag can be seen. Glue the straw to the inside of the fold.

5. Staple the open end of the paper.

Step 3

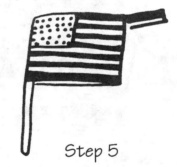

Step 5

## MORE IDEAS

- Instead of painting the details of the flag, use stickers or real items, such as maple leaves.
- Make tiny flags and attach them to toothpicks. These look great in centerpieces or stuck into sandwiches or other food items.
- Mirror-image pictures are an enjoyable "free art" activity. See if you can make some interesting designs using this technique. Then look closely at the designs and describe the kinds of things they look like. Many times a random design will look like a picture of an animal or object.

# Index

# Index (cont.)